IMAGES
of America

NORTH GEORGIA'S
DIXIE HIGHWAY

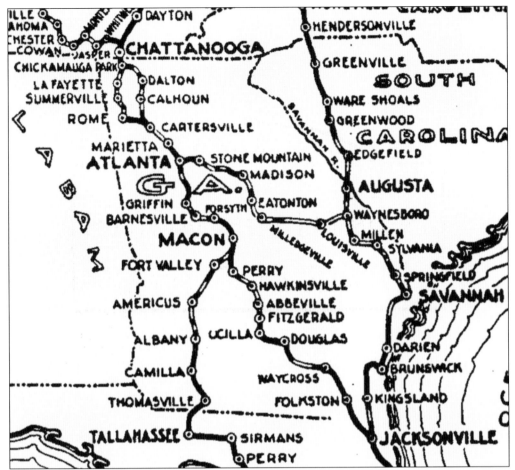

Above is the official routing map through Georgia from *The Dixie Highway* magazine in May 1924. The eastern road through north Georgia was known as the "Battlefield Route" and went through the towns of Dalton, Calhoun, Cartersville, and Marietta before reaching Atlanta. The eastern route was 126 miles, while the western route through Rome was 139 miles. The darker sections of the road depicted on the map indicate improved surfaces; the lighter coloring shows sections that were only graded. (Courtesy of Jeffrey L. Durbin.)

ON THE COVER: Charles Dupree (driver) and Herbert Clay ride the Marietta city streets in 1915 in a Maxwell Runabout. Members of the Clay family were long-standing public servants. Clay was mayor of Marietta from 1910 to 1911 and served as president of the Georgia Senate. His father, Alexander Clay, was a U.S. senator and held other elective offices. His brother, Gen. Lucius Clay, administered Germany after World War II and gave the order for the Berlin Airlift. (Courtesy of Georgia Archives, Vanishing Georgia cob243.)

IMAGES
of America

NORTH GEORGIA'S
DIXIE HIGHWAY

Amy Gillis Lowry
and Abbie Tucker Parks

ARCADIA
PUBLISHING

Published by Arcadia Publishing
Charleston SC, Chicago IL, Portsmouth NH, San Francisco CA

Printed in the United States of America

Library of Congress Catalog Card Number: 2007921338

For all general information contact Arcadia Publishing at:
Telephone 843-853-2070
Fax 843-853-0044
E-mail sales@arcadiapublishing.com
For customer service and orders:
Toll-Free 1-888-313-2665

Visit us on the Internet at www.arcadiapublishing.com

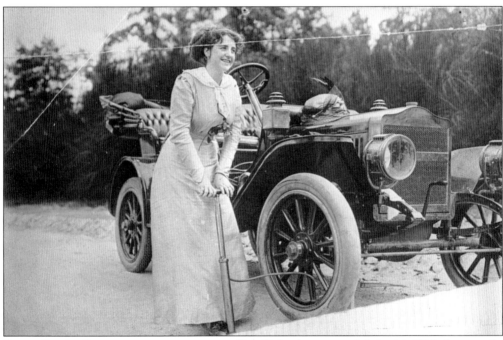

Regina Rambo Benson pumps air into a tire of her Columbia automobile in this 1910 photograph.
She was reportedly the first woman to drive around the state of Georgia in a touring automobile.
She also rode in the Glidden Tour, an American Automobile Association (AAA) annual event
held from 1902 to 1913 to promote the reliability of the automobile. (Courtesy of Georgia Archives,
Vanishing Georgia cob716.)

CONTENTS

ACKNOWLEDGMENTS

The staff at the Georgia Archives, especially those persons who work with the Vanishing Georgia Collection, deserves special recognition for its assistance throughout the process of assembling information and photographs for this project. The Vanishing Georgia Collection is a compilation of over 18,000 photographs that records 100 years of the everyday life of Georgians. The Vanishing Georgia Collection is available to the general public and can be accessed through the Digital Library of Georgia at the University of Georgia.

The authors would also like to thank the following:

Willie Ray Johnson, park ranger/historian, and Retha Stephens, park ranger/curator, from Kennesaw Mountain National Battlefield Park for their invaluable help in compiling photographs, history, background information, and other materials for this book;

The members of the present-day Georgia's Dixie Highway Association, a cooperative tourism project for Catoosa, Whitfield, Gordon, Bartow, and Cobb Counties to promote "Drivin' the Dixie" from Ringgold to Marietta;

Ellen Archer and Beth Grubbs for their special contributions;

Our families, who did without while we did the book; and

Jeffrey L. Durbin and Leslie Sharp for their photographs, postcards, and especially for their enthusiasm and knowledge, which gave the present-day Georgia's Dixie Highway Association its momentum.

Amy Gillis Lowry
Abbie Tucker Parks
January 2007

INTRODUCTION

The automobile traveler's sole guide was a painted design on telegraph and telephone poles: a white band on top and bottom and a red band in the middle with "DH" written in white. Yet those two letters opened up an entirely different world to Northern and Midwestern adventurers bound for the rural South. At the beginning of the 20th century, when the automobile was new and a toy of the rich, roads between cities were packed dirt and passable only in good weather. Getting lost was a likely occurrence, as few towns and thoroughfares possessed any identifying markers. For most Americans, rail travel was cheaper, quicker, and more reliable. Those individuals intrepid enough to explore Dixie in an automobile were rewarded with a warmer climate, distinct scenery, views of historic places, and interactions with native residents. In return, their traveling needs created an automobile-based tourist economy that transformed the South and the rest of the nation as well.

Advocates for automobiles and good roads sought to make interstate travel smooth and predictable. Carl Graham Fisher, a founder of the Lincoln Highway, became interested in a clearly marked north-south route after purchasing development land in Miami Beach, Florida. He hoped to attract recreational travelers and potential real estate buyers to his new playground in the sun. In 1914, he proposed a meandering connection from his native Hoosier land to Dixieland that would afford stops in various towns and cities to give visitors places to rest, refuel, and enjoy local attractions. Fisher's efforts resulted in the formation in 1915 of the Dixie Highway Association, a private initiative to promote good roads. From 1916 to 1927, the association was headquartered in Chattanooga, Tennessee, and held meetings around the Southeast to decide routing and discuss road conditions. The organization also published a monthly magazine, *The Dixie Highway*, to promote the highway.

So many eager communities applied to the Dixie Highway Association for a place on the map that the association designated both Western (through Indianapolis, Louisville, Nashville, Chattanooga, Atlanta, and Tallahassee) and Eastern (through Detroit, Cincinnati, Lexington, Knoxville, Augusta, Savannah, and Jacksonville) Divisions, with additional spurs and loops through the Midwest. Both divisions started in Sault Sainte Marie, Michigan, (near the Canadian Border) and ended in Miami, with various east-west ribs connecting the two routes. Early roads were constructed with local government and business funding; the federal government started to provide matching grants after 1916. The two-lane road surfaces were gravel, macadam, or poor-quality asphalt, later upgraded to paved brick or concrete. The association allowed for differing conditions, but all roads had to meet minimum standards or risk removal from the route.

Due to successful lobbying by local communities, the Western Division of the Dixie Highway in north Georgia had two paths from Chattanooga to Cartersville: an eastern route via Dalton and a western route via Rome. The eastern path was slightly shorter and more heavily traveled (126 miles versus 138 miles in 1924). After leaving Chattanooga, the original eastern route went through Rossville, Chickamauga Battlefield, Ringgold, Tunnel Hill, Rocky Face, Dalton, Resaca, Calhoun, Adairsville, Cassville, and Cartersville. South of Cartersville, the two routes converged and continued on through Emerson, Acworth, Kennesaw, and Marietta before reaching Atlanta.

Some of these communities were originally Cherokee villages, but all of them owed their growth to the Western and Atlantic Railroad, along whose corridor they were situated. The local economies in the early 20th century were largely dependent upon the railroad, cotton farming, and cotton mills. The Dixie Highway passed directly through the downtowns of these communities and accelerated economic growth in their central business districts.

In addition to advancing the towns, boosters of the Dixie Highway also promoted tourist sites such as Civil War battlefields, Native American settlements, and natural wonders. The War Between the States was still a living memory in the early 20th century, and the eastern section of north Georgia's Dixie Highway was also known as the "Battlefield Route" or the "Johnston-Sherman Link," as it followed Union general William T. Sherman's series of battles and engagements with Confederate general Joseph E. Johnston in the Atlanta campaign. Like the railroad before it, the Dixie Highway also roughly followed the Cherokee trade route through north Georgia, known as the "Peachtree Trail." Attractions related to Native American history such as New Echota (the last capital of the Cherokee Nation) and the Etowah Indian Mounds benefited from the highway's proximity. The highway also spawned the development of new tourist attractions, such as Rock City on Lookout Mountain in Georgia. Local highway chapters and organizations actively planted flowers and trees along the route, not only to beautify the road and their communities, but also to attract motorists. Automobile tourism was thus born in north Georgia.

With improvements to what had been local roads, commercial development was stimulated along the route. At first communities established free tourist tent camps for overnight guests. Roadside parks and picnic tables were situated by the highway for rest and meal stops. The Works Progress Administration (WPA) and the National Park Service built a series of five interpretive picnic pavilions along the route in north Georgia to highlight the Atlanta campaign of the Civil War. Entrepreneurs built tourist courts, cabins, inns, and motels along with restaurants, cafés, diners, hot-dog stands, and roadside markets to serve the new interstate travelers. Filling posts, service stations, and car dealerships were opened to accommodate the emerging automobile.

Industry also flourished near the highway. In the Dalton area, local people hung handmade chenille bedspreads for sale to passing motorists. Many patterns were produced, but the most popular peacock design gave this section of the Dixie Highway the nickname "Peacock Alley." Local factories began to produce the tufted patterns in coverlets, robes, toilet tank sets, and scatter rugs. The manufacturing ultimately evolved into the area's modern carpet industry.

By 1925, the federal government had begun to invest funds in construction and establishment of an interstate highway system with numerical designations: odd numbers for north-south roads and even numbers for east-west roads. Standardized black-and-white, shield-shaped signs replaced the named interstate highways, such as the Lincoln, Bankhead, and Dixie. The numbering program fragmented the Dixie Highway into several U.S. route designations. Much of the Dixie Highway in Georgia and Florida became U.S. Route 41. By the time the Dixie Highway Association disbanded in 1927, nearly 4,000 mile of roads had been upgraded along the designated routes. The most direct path from the Great Lakes to Florida was not completely finished until the fall of 1929. A Dixie Highway motorcade of 200 cars stretched eight miles long to celebrate the dedication of the final section from Chattanooga to Atlanta on November 4. At the height of that year's vacation season, over 800 tourist automobiles were expected daily.

After Georgia and Florida sections of the Dixie Highway were re-designated as U.S. Route 41, the highway continued to serve as the main travel route through north Georgia for much of the 1920s through 1950s. Tourist travel diminished markedly during World War II but boomed in the postwar years, leading the way to construction of a new Highway 41 that bypassed the downtowns of Adairsville, Cartersville, Emerson, Acworth, Kennesaw, and Marietta. Tourist-dependent businesses moved out to the new "Four-Lane," and the downtowns suffered economic decline. The completion of the limited-access Interstate 75 effectively ended the era of the Dixie Highway in north Georgia. The last stretch of I-75 to be finished in the 1970s was near Cartersville; coincidently it also lies parallel to the last leg of the Dixie Highway to be paved. In this volume, we celebrate the old two-lane Dixie Highway, parts of which today are still reminiscent of its heyday.

OFFICIAL MAP
OF THE
DIXIE HIGHWAY
ISSUED BY
DIXIE HIGHWAY ASSOCIATION
CHATTANOOGA, TENN.
NOVEMBER 1ST, 1923

Only Official Routing of Dixie Highway—Eastern Branch

EASTERN BRANCH

Sault Ste. Marie, Mich., to Mackinaw	65 Miles
Macinaw to Alpena	119 Miles
Alpena to Bay City	137 Miles
Bay City to Bad Axe 79 Miles	
Bad Axe to Port Huron 63 Miles	
Port Huron to Algonac 25 Miles	
Algonac to Detroit 46 Miles	
	213 Miles
Bay City to Saginaw	16 Miles
Saginaw to Detroit	95 Miles
Detroit to Toledo	61 Miles
Toledo, Ohio, to Lima	78 Miles
Lima to Dayton	74 Miles
Dayton to Cincinnati	61 Miles
Cincinnati, Ohio, to Lexington (via Georgetown)	85 Miles
Via Cynthiana, Ky 96 Miles	
Lexington, Ky., to Mt. Vernon	63 Miles
Mt. Vernon to Jellico	83 Miles
Jellico to Knoxville	72 Miles
Knoxville, Tenn., to Chattanooga	132 Miles
Chattanooga to Atlanta (via Dalton)	120 Miles
Atlanta, Ga., to Macon	95 Miles
Macon to Waycross	172 Miles
Waycross to Jacksonville	77 Miles
Jacksonville, Fla., to St. Augustine	41 Miles
St. Augustine to Daytona	73 Miles
Daytona to West Palm Beach	195 Miles
West Palm Beach to Miami, Fla.	67 Miles
Total	1987 Miles

WESTERN BRANCH

Sault Ste. Marie, Mich., to Mackinaw	65 Miles
Mackinaw to Petosky	38 Miles
Petosky to Traverse City	72 Miles
Traverse City to Manistee	67 Miles
Manistee to Muskegon	94 Miles
Muskegon to Grand Haven	13 Miles
Grand Haven to South Haven 54 Miles	
South Haven to St. Joseph 30 Miles	
St. Joseph to Niles 24 Miles	
	108 Miles
Grand Haven to Grand Rapids	32 Miles
Grand Rapids to Kalamazoo	50 Miles
Kalamazoo to Niles	59 Miles
Niles to South Bend	11 Miles
South Bend to Indianapolis	139 Miles
(Via Logansport-Michigantown)	
Indianapolis to Paoli	99 Miles
Paoli to Louisville	49 Miles
Louisville to Horse Cave	84 Miles
(Horse Cave to Mammoth Cave) 14.4 Miles	
Horse Cave to Bowling Green	35 Miles
Bowling Green to Springfield	43 Miles
Springfield to Nashville	30 Miles
Nashville to Chattanooga	160 Miles
Chattanooga to Atlanta (via Rome)	139 Miles
Atlanta to Macon	95 Miles
Macon to Thomasville	167 Miles
Thomasville to Tallahassee	35 Miles
Tallahassee to Gainesville	162 Miles
Gainesville to Ocala	44 Miles
Ocala to Orlando	88 Miles
Orlando to Haines City	40 Miles
Haines City to Fort Myers	147 Miles
Fort Myers to Marco, Fla.	50 Miles
Total	2107 Miles

CHICAGO TO INDIANAPOLIS-DAYTON, OHIO

Chicago to Danville	135 Miles
Danville to Crawfordsville	41 Miles
Crawfordsville to Indianapolis	45 Miles
Indianapolis, Ind., to Dayton, Ohio	108 Miles
Total	329 Miles

This official map of the Dixie Highway was issued by the Dixie Highway Association in November 1923 and published in *The Dixie Highway* magazine in May 1924. As in the earlier map, the darker sections designate improved surfaces; the lighter show graded-only sections. (Courtesy of Jeffrey L. Durbin.)

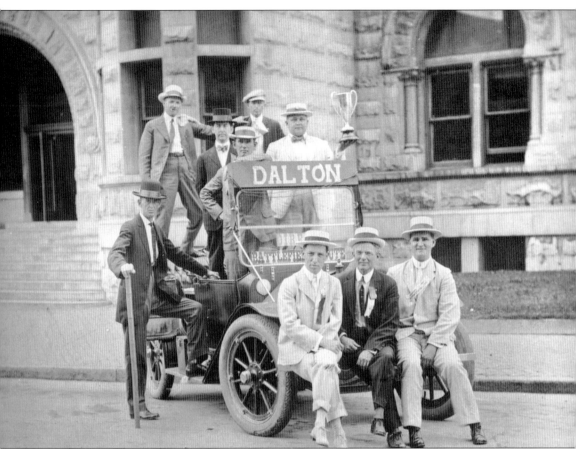

In 1914, representatives from the cities of Dalton and Adairsville joined a motorcade to Chattanooga to lobby the Dixie Highway Association to include the road through their communities. Dalton was in direct competition with Rome for the road and developed the designation "Battlefield Route" (as posted on the car's windshield) to promote its cause. The delegation pictured here won a cup for having the largest number of promoters. Representatives from Adairsville sitting on the front bumper are, from left to right, Frank S. Pruden, B. A. Tyler, and ? Bishop. The Dalton men are, from left to right, Tom Boaz (with the cane); J. G. McLellan; Dr. J. L. Jarvis; Louis Crawford (leaning on the sign); J. J. Copeland; and Paul B. Fite, the car's owner and holder of the cup. In the end, the Dixie Highway Association added both routes through north Georgia. (Courtesy of Georgia Archives, Vanishing Georgia wtf273.)

One

CRANK 'ER UP

Although the automobile began as a commodity only the wealthy could afford, within a few decades, manufacturers were able to mass-produce inexpensive models. In the early 1900s, about 24 American companies were making automobiles, one for every 1,000 people; by 1930, that number had dropped to one for every five people.[1] Most blue-collar workers would not be able to afford an automobile until after World War II, but it had become an essential possession for the middle class.[2] Farmers, too, found the automobile indispensable.

Rural roads and country bridges needed to be upgraded for vehicular travel. Hotel owners, restaurants, and automotive businesses along the Dixie Highway contributed funds, and local governments issued bonds to help pay for construction. Still, competing interests made completion difficult. The Dixie Highway Association had the task of synchronizing the building efforts of more than 50 counties in 10 states while struggling for a limited pool of funds against rival highway associations and other communities not selected for the route.[3] As highway building accelerated, general taxation rather than tolls prevailed as the way to pay for necessary road improvements. The State of Georgia created its highway department in 1916 and initiated a gasoline tax in the 1920s. Additional revenues came from tag fees and from the national government. The 1916 and 1921 Federal Road Acts allotted funds to states that created their own highway departments and matched those funds on a 50/50 basis.

Traffic on the Dixie Highway was heavier in the fall when tourists headed south to Florida and in the spring when they reversed their direction for home. The Georgia Highway Department conducted daily traffic counts on the Dixie Highway. One such census in 1927 during "snowbird" season yielded 285 Georgia automobiles, 243 foreign automobiles, 35 Georgia trucks, 6 foreign trucks, and 13 horses on the Cartersville-Marietta segment.[4] The department not only concerned itself with construction and maintenance, but also with beautification. It prohibited right-of-way signage and encouraged garden clubs, women's clubs, the Daughters of the American Revolution, and the United Daughters of the Confederacy to participate in tree planting and beautification efforts.

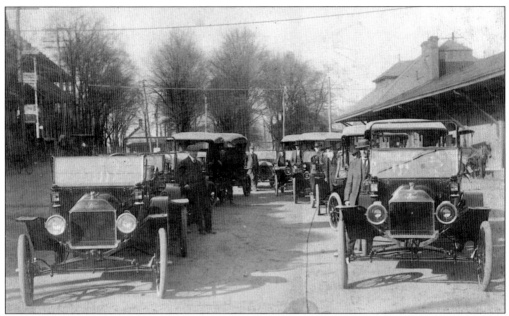

Brand-new black Model Ts arrive at the Cartersville Depot in 1915. A. G. "Gaz" White's Ford dealership was located on the Cartersville Square. Although earlier Fords had been available in Brewster Green, Red, Blue, and Gray, after 1913, they came only in black to optimize the assemble line production. Ford allegedly said that the public could have Model Ts "in any color, so long as it's black." (Courtesy of Georgia's Dixie Highway Association.)

Matt Harris is the driver and Renzo Wiggins is his front-seat passenger in what is reportedly the first car in Ringgold in the early 1900s. The others are unknown, with the exception of Rich Anderson in the goat wagon in the left background. (Courtesy of George Hendricks.)

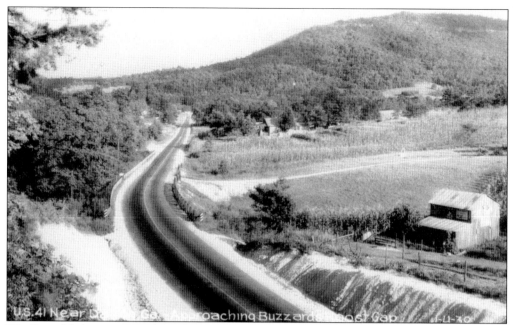

The Dixie Highway curves through Buzzard's Roost Gap between Rocky Face and Dalton in this c. 1940 postcard. "Buzzard's Roost" was so named for an early settler who called himself "King Buzzard" and claimed "where the King Buzzard roosted, the other buzzards gathered." Dalton was originally called Cross Plains for the intersection of east-west and north-south wagon trails. It was renamed for Mary Dalton, the daughter of a U.S. senator from Massachusetts. (Courtesy of Jeffrey L. Durbin.)

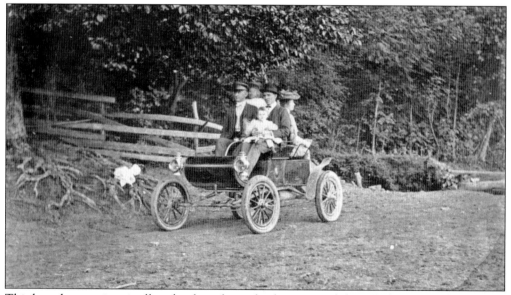

This horseless carriage is alleged to have been the first automobile in Dalton around 1903. The Oldsmobile's owner and driver is Henry Losson Smith. Smith was one of the first graduates of the new Georgia School of Technology (now the Georgia Institute of Technology). Mr. and Mrs. Jesse Smith, their daughter Lulu, age six, and another unidentified child are the passengers. (Courtesy of Georgia Archives, Vanishing Georgia wtf231.)

From left to right, Grace Bogle, Emmie Snow, Eugenia Sapp, William Sapp, and Dorothy Sapp sit on the car running board for this 1921 portrait taken in Dalton. The automobile is notable for having one of the first enclosed interiors. (Courtesy of Georgia Archives, Vanishing Georgia wtf113.)

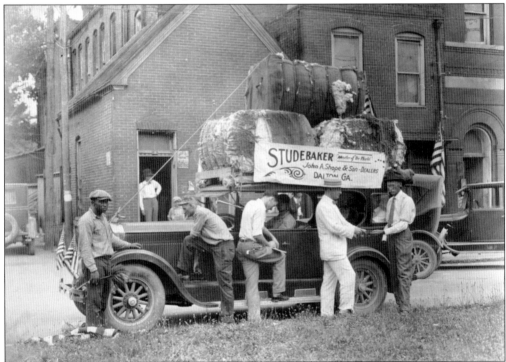

John A. Shope and Son was a Studebaker ("Master of the World") dealer in 1920s Dalton. This Studebaker, with three bales of cotton on top, was parked on King Street and admired by, from left to right, ? Booker, Charlie Deck, unidentified boy, ? Varner, Herman Shope, Harvey Britton (front seat), Charlie Dupree, unidentified boy (back seat), and John A. Shope. (Courtesy of Georgia Archives, Vanishing Georgia wtf307.)

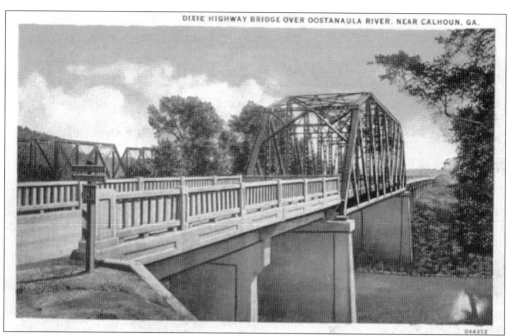

This 1940s postcard depicts the Resaca Bridge over the Oostanaula River. The $90,000 bridge was noted for excellent fishing. Visible in the background are the trestles of the railroad bridge, the pillars of which are antebellum. James Andrews and the raiders tried and failed to burn the wooden trestle that sat on top of the pillars during the Civil War incident known as the "Great Locomotive Chase." (Courtesy of Gordon County Historical Society.)

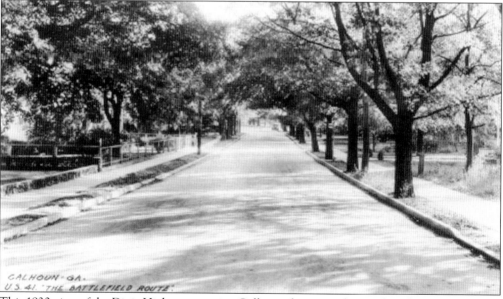

This 1930 view of the Dixie Highway entering Calhoun shows a wide paved road, curbs, sidewalks, and street trees—everything the promoters sought to provide the traveling public. Originally called Oothcalooga for the site of a Cherokee village, Calhoun was renamed in honor of John C. Calhoun, a U.S. vice president, senator from South Carolina, and a staunch proponent of states' rights and slavery. (Courtesy of Gordon County Historical Society.)

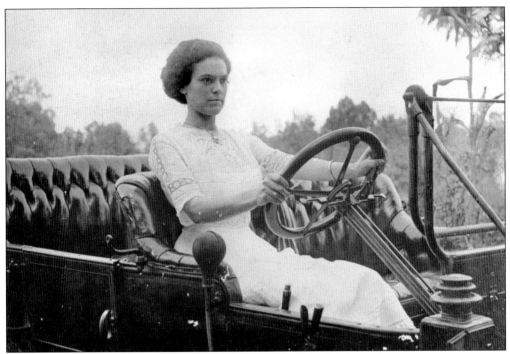

Tennie Mae Owens sits behind the wheel of an early automobile with the steering wheel on the left side in this photograph from around 1905 in Calhoun. (Courtesy of Georgia Archives, Vanishing Georgia gor448.)

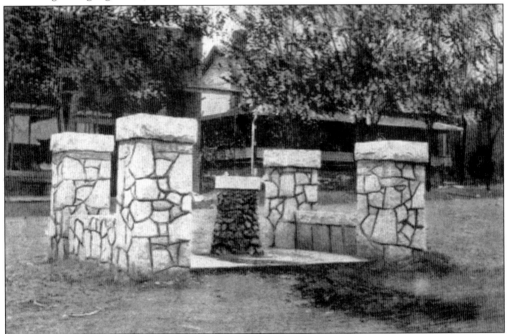

A drinking fountain stood in the middle of an unpaved South Wall Street in downtown Calhoun in 1908. Such an obstruction would have been a hazard for automobiles, and it was removed before the street was paved. (Courtesy of Gordon County Historical Society.)

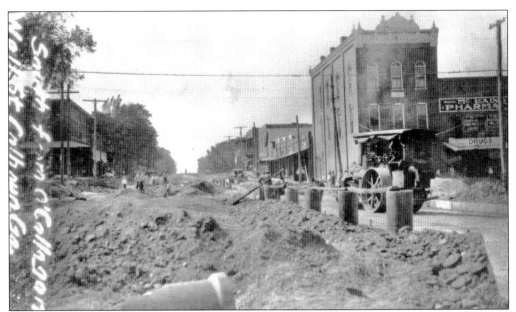

In 1918–1919, the area around the Gordon County Courthouse was paved, including North Wall Street, South Wall Street, and Court Street. This view, from the perspective of the courthouse, looks south along Wall Street. Note the paving apparatus in the middle of the street and McLain's Pharmacy, housed on the south side in the Victorian-era downtown buildings. (Courtesy of Gordon County Historical Society.)

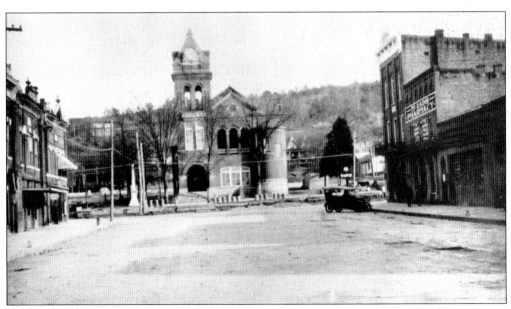

This view of Court Street looks east to the Gordon County Courthouse after the street was paved. Mount Alto is behind the courthouse. (Courtesy of Georgia Archives, Vanishing Georgia gor507.)

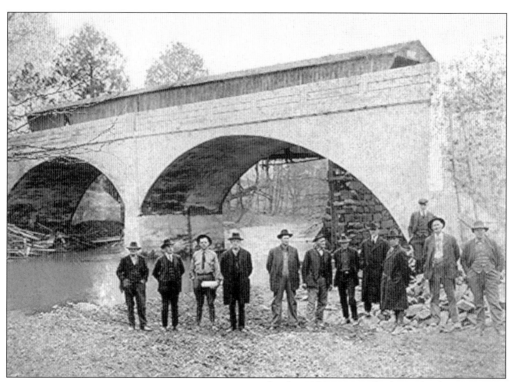

In the 1920s, a new highway bridge was constructed over Oothcalooga Creek south of Calhoun. Rex LeFevre, third from the left in this photograph, was the engineer for the project. The old covered bridge with stone pier supports can be seen in the background. (Courtesy of Gordon County Historical Society.)

Gilbert Austin (in the driver's seat) and Elmo Donaldson do not appear to be old enough to drive this 1916 Hudson. The headlights had to be lighted with a match. (Courtesy of Georgia Archives, Vanishing Georgia gor497.)

As new roads were built in some places on the Dixie Highway, old sections would be circumvented. In the photograph taken here south of Calhoun, a two-span, concrete T-beam bridge with fence-type railings still stands on a road bypassed by a newer highway road built in 1948. The bridge was built around 1924 by the Georgia Highway Department, the earliest such bridge installed for vehicular traffic on the Dixie Highway. (Courtesy of Jeffrey L. Durbin.)

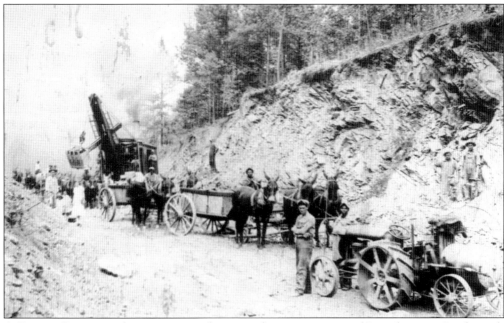

A Bartow County road crew is paving between the two crossings of Pumpkinvine Creek south of Cartersville. The machinist for the road crew, Telford Kelly, is the white man in the forefront; the Donahoo family watches on the left. The crew pulled a lever in the "dump wagons" to open doors to drop out dirt and rocks. Two men at the far right are using an air jackhammer attached to the air compressor in front. (Courtesy of Bartow History Center.)

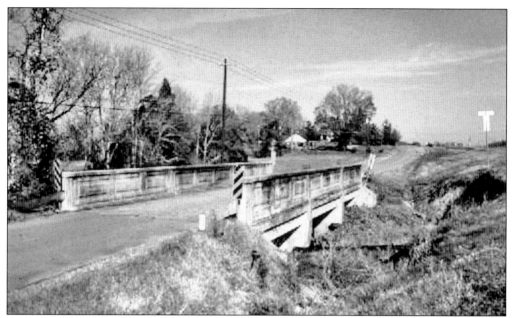

For miles between Calhoun, Adairsville, and Cartersville, a bypassed Old Dixie appears and vanishes numerous times, still in use today as an access road through the rural countryside. This T-beam bridge built around 1922 with paneled concrete railing spans a bypassed route north of Adairsville. This bridge, the bridge shown on page 19, and three others in the area are eligible for inclusion on the National Register of Historic Places.[5] (Courtesy of Jeffrey L. Durbin.)

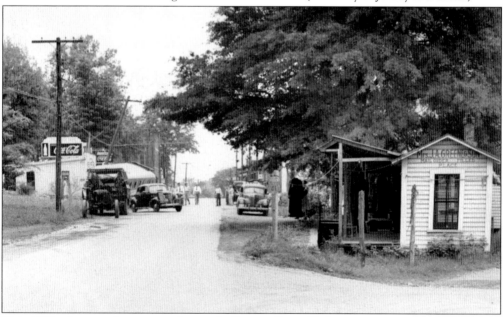

This 1930s photograph captures the north Georgia Dixie Highway in microcosm. From left to right, the Little Rock Café, a roadside eatery, advertises Coca-Cola; a bus has run off the road and hit an electric pole; an automobile with suitcases on the bumper has stopped; people mill about to view the scene; and Mrs. J. A. Greene and Son chenille bedspread store—"Mail Order . . . Filled Place"—is open for business. (Courtesy of Bartow History Center.)

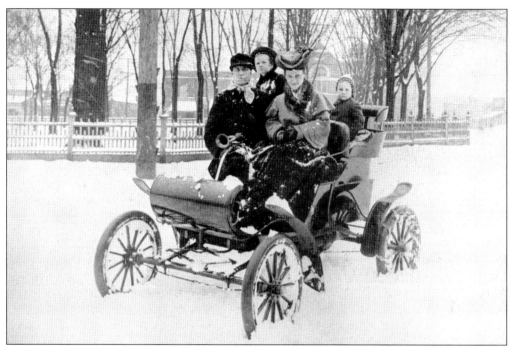

The first automobile in Marietta, pictured here on the Marietta Square in 1902–1903, was an Oldsmobile. Bolan and Ida Brumby pose for a snowy picture with their children Lawrence (left) and Bolan Jr. (Courtesy of Georgia Archives, Vanishing Georgia cob357b.)

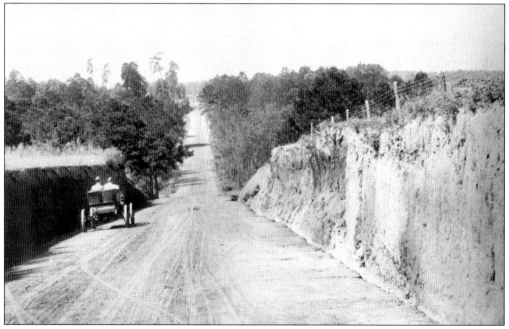

An early Cobb County road is dug and graded for automobile traffic, but rain and mud could easily make it impassable. The president of the Atlanta Auto Club observed in 1918 that the road between Marietta and Atlanta was "the weakest link in the whole Dixie Highway."[6] (Courtesy Cobb Landmarks and Historical Society.)

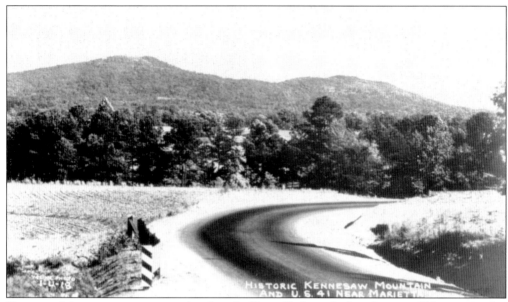

Kennesaw Mountain towers over a bend in the Dixie Highway before the city of Marietta in this early picture postcard. (Courtesy of Larry O. Blair.)

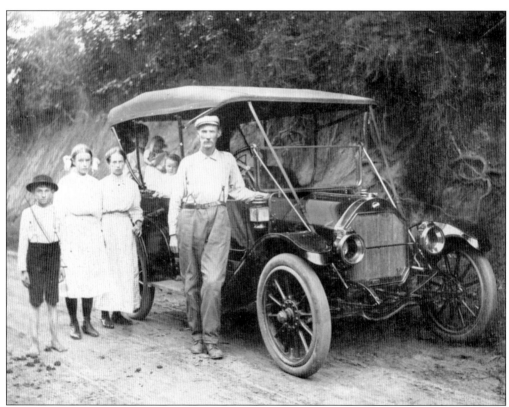

Richard L. Brasill and family pose beside their car on Cherokee Street in Marietta about 1912 for photographer Armour Moon. (Courtesy of Georgia Archives, Vanishing Georgia cob154.)

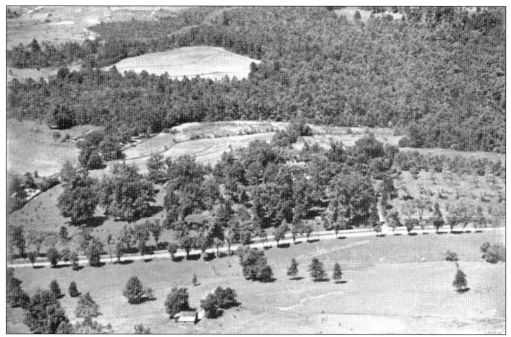

This aerial view of the Dixie Highway gives a sense of the sparseness of development along the road in 1935, even close to downtown Marietta. This section of the highway actually had two parallel lanes. The driveway running up from the highway led to the home known as Oakton. (Courtesy of Georgia Archives, Vanishing Georgia cob811.)

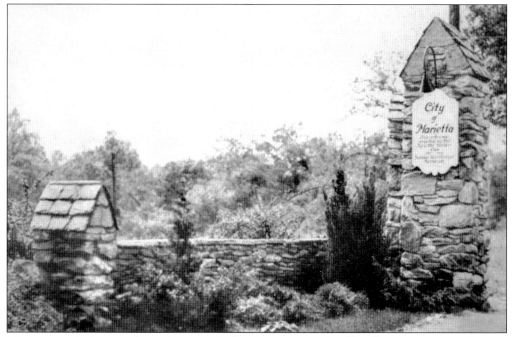

Marietta marked its south city limits with this distinctive rock-pillared monument, seen here in the 1930s. The sign welcomed visitors to the city along the Dixie Highway until the late 1970s. (Courtesy of Joe McTyre.)

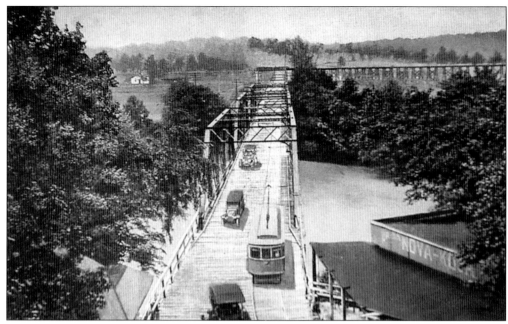

A 1930 postcard depicts the end of the Dixie Highway in Cobb County. The bridge crosses the Chattahoochee River into the city of Atlanta. Cars had to share access with the electric streetcar, which ran regularly between Marietta and Atlanta. (Courtesy of Joe McTyre.)

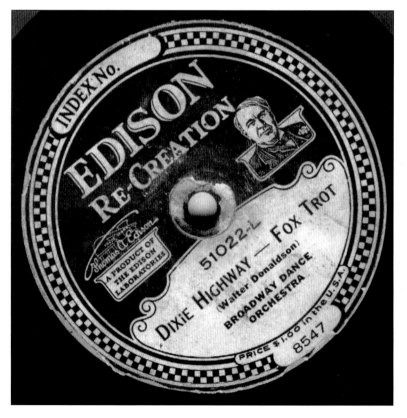

Maybe it was not as famous as Bobby Troup's "(Get Your Kicks on) Route 66," but the Dixie Highway seeped into popular culture with its own 1922 song with music by Walter Donaldson and lyrics by Gus Kahn. They also collaborated on such hits as "Makin' Whoopee." Part of the chorus went, "All my cares will fly 'way / When I'm wending my way / Down the Dixie Highway / I'm going home." (Courtesy of Jeffrey L. Durbin.)

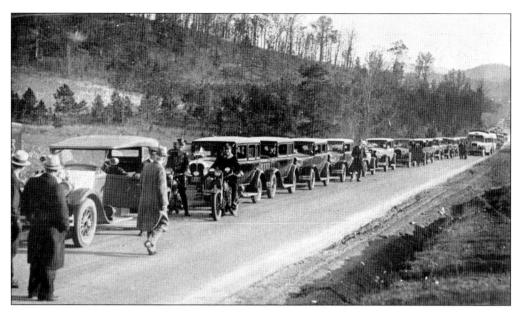

A Dixie Highway motorcade of cars, buses, and motorcycles wheels into Dalton in the 1920s. The motorcade was possibly connected with the opening in 1920 of the roadway to year-round traffic; with the 10th Anniversary of the Dixie Highway in 1925; or with the completion of the direct paved route in 1929. Numerous Dixie Highway motorcades served to promote the road. (Courtesy of Georgia Archives, Vanishing Georgia wtf184.)

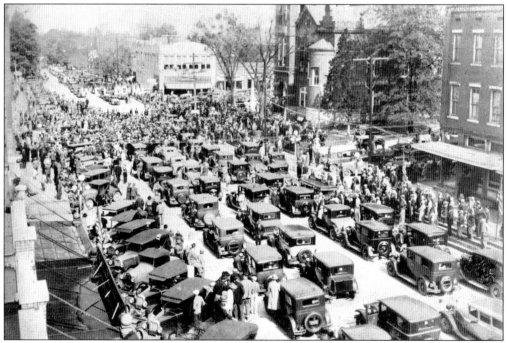

Another motorcade photographed in Calhoun purportedly celebrated the completion of the direct route of the Dixie Highway. The 1929 motorcade retraced the Battlefield Route from Atlanta to Chattanooga. A welcome sign is strung across the roadway just past the Gordon County Courthouse. (Courtesy of Georgia Archives, Vanishing Georgia gor332.)

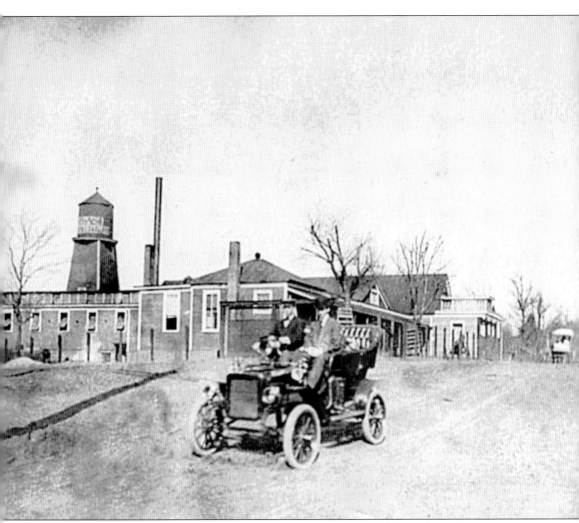

A chauffeur drives what appears to be an early REO automobile with its distinctive square radiator. REO automobiles were known for their quality workmanship, durability, power, and innovation. Early automobiles had to share the road with horses and buggies, as shown here in Cobb County. Those who were well-to-do employed chauffeurs to drive their horseless buggies, just as they had earlier employed coachmen for their carriages. (Courtesy of Cobb Landmarks and Historical Society.)

Two

PUT IT IN GEAR

Late-19th- and early-20th-century popular literature, magazines, travel guides, advertisements, and art presented an idealized version of the South as romantic and charmingly rustic. Florida especially was depicted as a recreational paradise in direct contrast to the industrialized North. *The Dixie Highway* magazine perpetuated the ideal by telling its readers that "Scenery and climate mingled with the historical attractions and romantic traditions of the old South are sufficient lures to bring all of the tourists the South can possibly take care of for some years to come."[7] Viewed from the windshield of the interstate traveler, north Georgia's landscape was slightly mountainous and wooded and was traversed by numerous creeks and some larger rivers. The terrain at the southern edge of the Appalachian Mountains did make for an appealing drive, even if some parts were less than bucolic. A 1940 guidebook declared, "Most of the farmhouses are unpainted, but bright flowers bloom in the grassless yards."[8]

Before World War II, most Dixie Highway travelers were more economically advantaged than the populace they encountered, especially in north Georgia. Most of the indigenous populace worked on subsistence, tenant, and sharecropped farms growing crops such as cotton, corn, sorghum, wheat, peaches, and apples. Bad weather, depleted soil, and the boll weevil, however, hampered cotton farming even before the Great Depression. Some rural residents turned to making moonshine to earn a living. Legally mandated temperance began in 1908 in Georgia (12 years before Prohibition), and much of the moonshine bootlegged to Atlanta was manufactured in the impoverished communities of the north Georgia mountains.[9] Local residents were fortunate to have cotton mills for employment in Dalton, Calhoun, Cartersville, Acworth, and Marietta. Other town residents pursued occupations supportive of the busy rail line and agrarian communities.

The 1930 combined population of five Dixie Highway counties (Catoosa, Whitfield, Gordon, Bartow, and Cobb) north of Atlanta was just under 108,000. In contrast, the city of Atlanta's population was more than twice that amount. Marietta was the largest town, with a population about 7,600. The larger towns had beautiful hotels serving railroad visitors, drummers, and summer tourists cooling off from climes even farther south. The county seats had town squares built around courthouses, except for Cartersville, whose square was oriented to its railroad depot. The importance of the railroad was reflected in the commercial buildings that emanated from the depots and the towns' streets, which aligned with the railroad tracks. The depot would gradually cease to be the point of welcome to the community as the automobile proliferated.

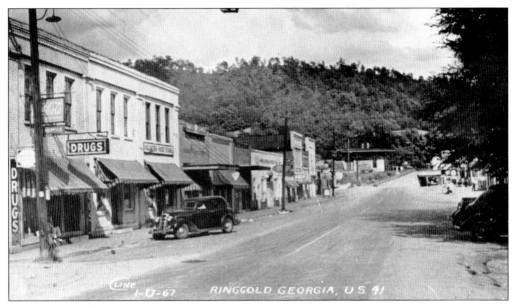

One of the first communities Dixie Highway travelers would see, Ringgold was a quiet farming community with a small downtown in the 1930s and 1940s, from which time this Cline postcard dates. Ringgold was incorporated in 1847, and its inhabitants saw much action in the War Between the States, including the Battle of Ringgold Gap and the end of the Great Locomotive Chase. (Courtesy of Georgia Archives, Vanishing Georgia cat001.)

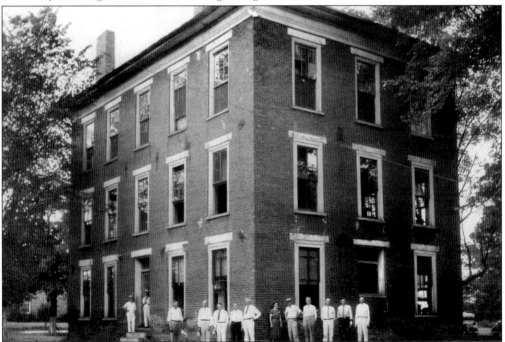

The three-story Catoosa County Courthouse in Ringgold was built in 1856 and reportedly was spared in the War Between the States because the third floor served as a Masonic hall. It was a common practice for Masonic lodges to share quarters. The present-day courthouse replaced it in 1939. (Courtesy of Georgia's Dixie Highway Association.)

28

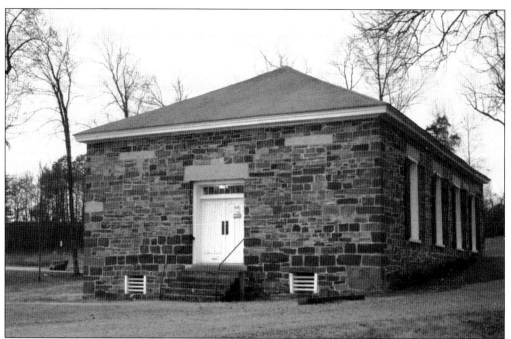

The Old Stone Church was constructed of sandstone around 1848. The rock walls are 21 inches thick and the floors are bloodstained from the church's use as a hospital following the Battle of Ringgold. The church is listed on the National Register of Historic Places. (Courtesy of Georgia's Dixie Highway Association.)

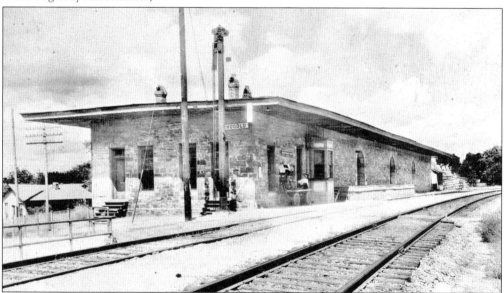

The Ringgold Depot, pictured in this c. 1930 postcard marked I-U-67, is listed on the National Register of Historic Places. Built in 1849, it is also one of five 19th-century Western and Atlantic depots still standing near the Dixie Highway's Eastern Division. Its sandstone walls were damaged during the Battle of Ringgold and subsequently repaired with limestone, giving it a two-tone effect. It has recently been renovated to be used for special events. (Courtesy of Georgia Archives, Vanishing Georgia cat002.)

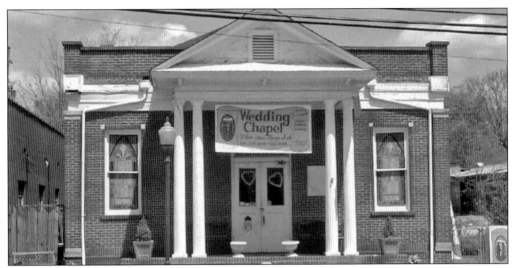

The "Biggest Little Wedding Chapel in the Area" is located opposite the courthouse in the 1926 Ringgold Methodist Episcopal Church. This local version of a Las Vegas wedding chapel has a slogan of "More than Saying 'I Do.' " The chapel is close to a blood lab so prospective couples can get the necessary paperwork and tests done quickly. (Courtesy of Georgia's Dixie Highway Association.)

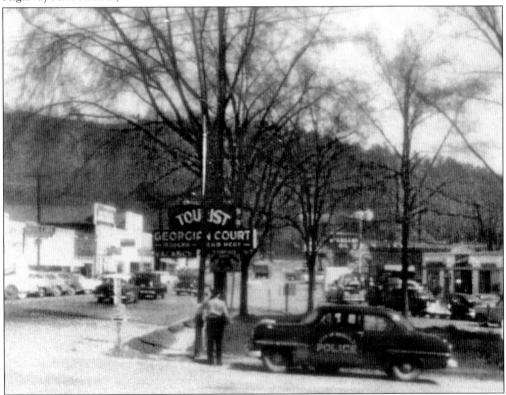

Until 1959, Ringgold had only one police car. As shown in this photograph, a parking space and a pay phone were officially reserved for police use in front of the Georgian Court tourist cabins on the Dixie Highway in the middle of town. (Courtesy of George Hendricks.)

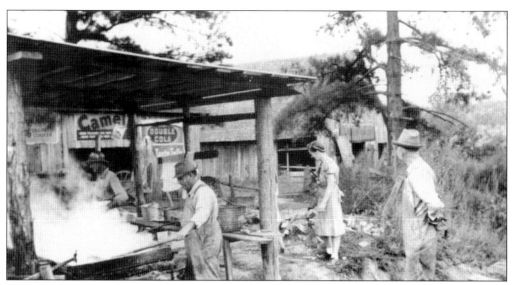

Dixie Highway travelers would have witnessed sorghum-syrup making in rural north Georgia. Sorghum stalks were crushed, and the extracted juice was boiled down into the syrup. One such operation was set up between Ringgold and Tunnel Hill in Catoosa County. Workers, pictured from left to right, are unidentified, Same Denman, Winnie Denman Huggins, and John Johnson. (Courtesy of Bradley Putnam.)

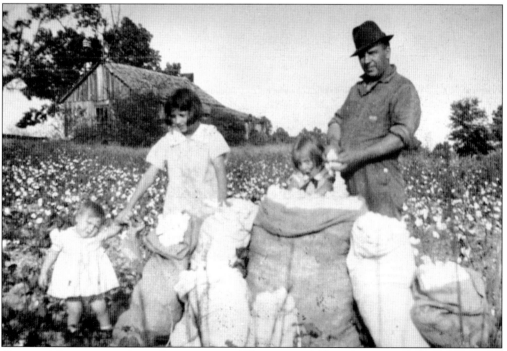

Cotton picking was another sight tourists would have seen. Although cotton production declined markedly in the 1920s and 1930s due to bad weather, poor soil, and the boll-weevil invasion, cotton was still a very important crop. In this 1938 photograph, a family of workers picks cotton on R. Lee Davis's farm in Whitfield County. (Courtesy of Georgia Archives, Vanishing Georgia wtf002.)

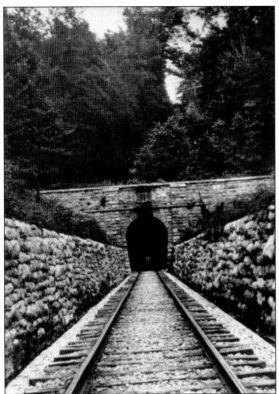

The town of Tunnel Hill was named for the railroad tunnel cut through Chetoogeta Mountain for the Western and Atlantic Railroad. The first train passed through in 1850. The tunnel was the scene of important engagements between the Union and Confederate forces for possession of the strategic railway. It was replaced by a larger tunnel in the 1920s to accommodate bigger and more modern trains. The tunnel is listed on the National Register of Historic Places. (Courtesy of Georgia Archives, Vanishing Georgia wtf224.)

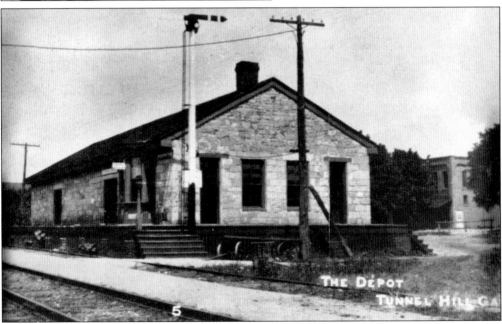

The Tunnel Hill depot was erected in 1848 with stones dug from the railroad tunnel. The signal in this 1905 photograph was activated by hand. The depot still stands today but is no longer in use by the railroad. The town of Tunnel Hill was incorporated in 1851; in the Dixie Highway era, old brick buildings lined the shady street. (Courtesy of Georgia Archives, Vanishing Georgia wtf222.)

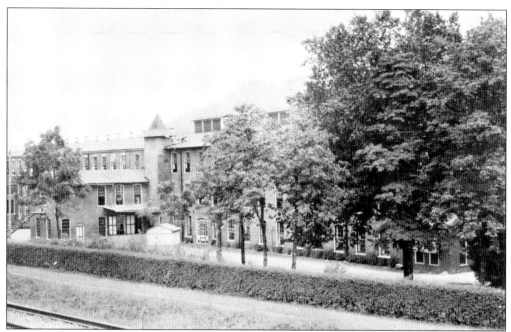

The red brick Crown Cotton Mill housed Dalton's first large-scale industry, "duck" (heavy canvas) cloth production. The 1885 Mill No. 1 building is on the National Register of Historic Places. In 1940, the mill village itself had six gas stations and two tourist camps in addition to the other Dalton businesses accommodating Dixie Highway travelers.[10] (Courtesy of Georgia Archives, Vanishing Georgia wtf060b.)

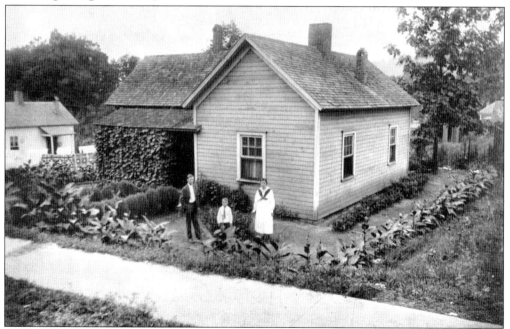

The Dalton textile mills held contests for the most attractive mill-house yard. A winning family poses in front of their home in this photograph from 1919. (Courtesy of Georgia Archives, Vanishing Georgia wtf260.)

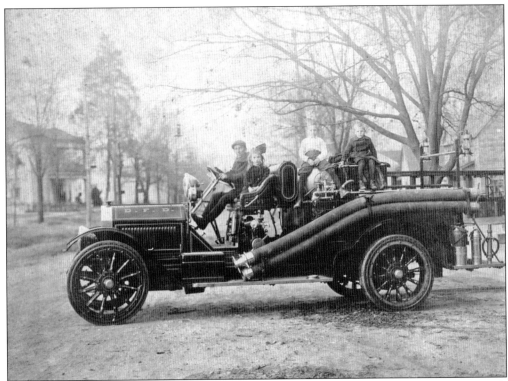

Hardy Springfield and his children, Lucille (left), Bud (center), and Bill, pose in this photograph from 1923 on a 1918 American LaFrance engine pumper. The fire truck was reportedly the first obtained by the Dalton Fire Department. Note the hoses and the fire extinguishers in the back of the truck. Springfield later became fire chief. (Courtesy of Georgia Archives, Vanishing Georgia wtf125.)

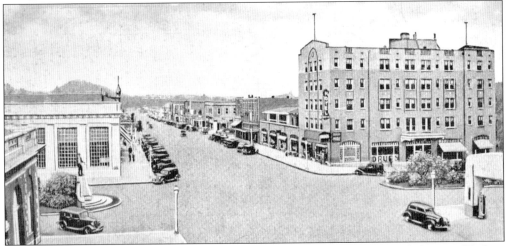

This 1930s Dalton postcard street scene looks north along Hamilton Street with the Hotel Dalton at right on the corner of Crawford and Hamilton Streets. Built in 1923, it replaced an earlier Hotel Dalton that burned in the April 1911 downtown fire. Visible on the right are the 1909 U.S. post office used as city hall and the Joseph E. Johnston Monument. (Courtesy of Georgia Archives, Vanishing Georgia wtf207.)

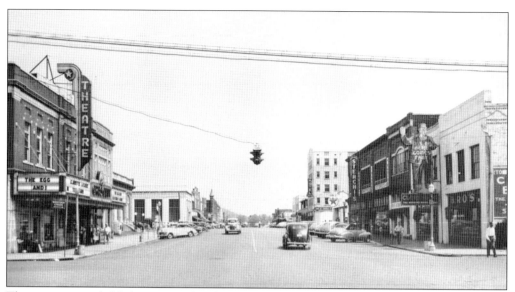

The same scene at left below is viewed in this 1947 postcard (I-U-91) from farther back. The Crescent Theatre on the left is playing *The Egg and I* starring Claudette Colbert and Fred MacMurray. The theater burned in the early 1960s. Visible on the right are, from front to back, Clark Brothers ("the working man's friend," with giant cutout sign of a man), Sterchi's Store, a Texaco service station, and the Hotel Dalton. (Courtesy of Georgia Archives, Vanishing Georgia wtf208.)

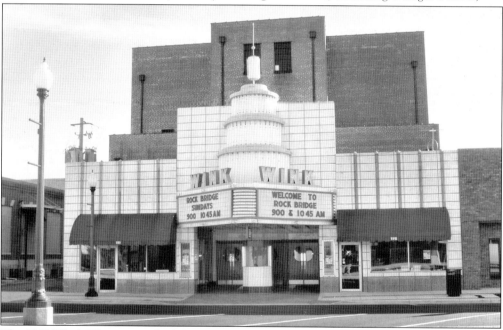

The 1938 Wink Theatre was built by J. C. W. Wink in downtown Dalton in art moderne style, with elements of both art deco (in the geometric design of the "wedding cake" atop the marquee) and streamline moderne (in the curved edges of the marquee). In contrast to the right-angle, pedestrian-oriented marquee of the earlier Crescent Theatre, the Wink's marquee is angled to the car in the street. The marquee and facade have changed little since then. (Courtesy of Georgia's Dixie Highway Association.)

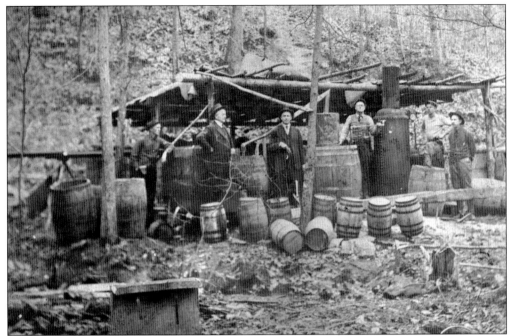

Law officers are in the process of destroying a moonshine still in this photograph from Gordon County in 1922. Many north Georgia families sustained themselves through hard times in the 1920s and 1930s with the sale of illegal liquor. (Courtesy of Georgia Archives, Vanishing Georgia gor115.)

Resaca was originally called Dublin by Irish railroad workers but was renamed by returning Mexican War veterans for their victory at Resaca de la Palma. One of the first and bloodiest battles of the Civil War's Atlanta campaign was fought around the highway in May 1864. The Resaca Town Hall is located in this Victorian house built in 1880. (Courtesy of Georgia's Dixie Highway Association.)

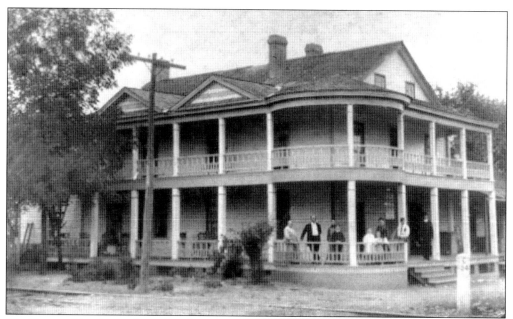

The Barnett Hotel near the railroad tracks in Resaca was originally a house built in 1869. Samuel Barnett expanded it to serve as a hotel. It may have also have served as a bank and post office over the years. It welcomed railroad passengers and early Dixie Highway travelers. (Courtesy of Gordon County Historical Society.)

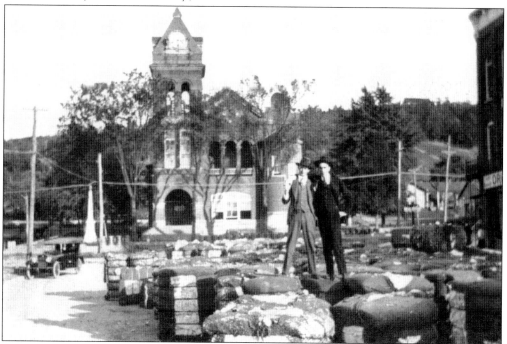

Tom Watts (left) and Dan Lay (right) stand atop bales of cotton that are being stored in the middle of Court Street in Calhoun in 1919. The Gordon County Courthouse in the background was completed in 1889 with assistance from William Dowling and W. L. Hillhouse. The courthouse was demolished in 1961. (Courtesy of Gordon County Historical Society.)

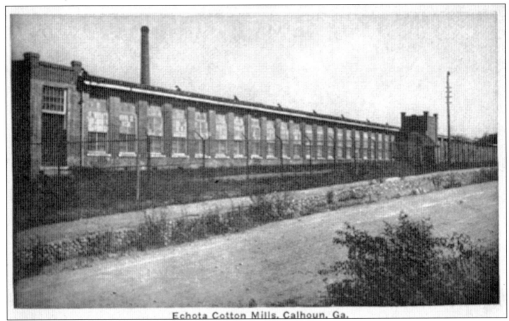

Echota Cotton Mills, Calhoun, Ga.

The Echota Cotton Mills and its mill village were adjacent to the Dixie Highway and illustrate the Southern way of life that was dependent on textile manufacturing in the early 20th century. Currently only the smokestack survives the mill. It is surrounded by a throw-weaving operation owned by Mohawk Industries. Many mill houses are still intact. The mill managers and supervisors resided in the larger, bricked homes. (Courtesy of Gordon County Historical Society.)

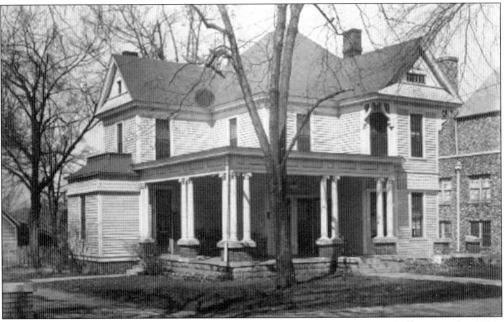

The Thomas Witherspoon Harbin Home was built on North Wall Street in Calhoun in the 1890s in the Queen Anne style. Harbin was an ordinary in Gordon County, a Georgia state senator, and the Echota Cotton Mill's first president. The house was razed in the 1960s. (Courtesy of Gordon County Historical Society.)

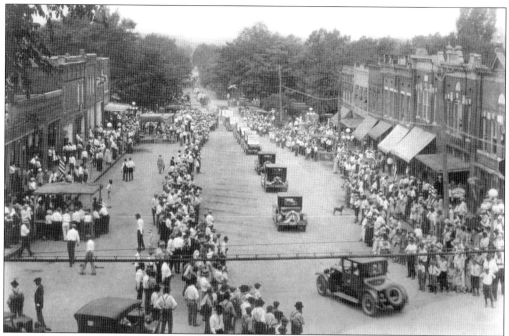

The automobile early infiltrated the quintessential community event: the Fourth of July parade. Here the cars join the procession along Court Street in Calhoun in 1926. (Courtesy of Gordon County Historical Society.)

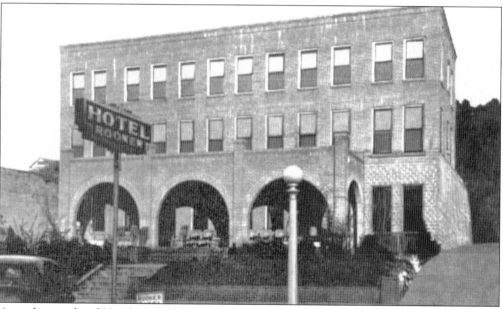

A newly completed Hotel Rooker graces North Wall Street in this 1935 postcard from Calhoun. This Rooker replaced an earlier one near the Oothcalooga Depot. Its Romanesque arches echo those of the Hicks home on the next page. The hotel has been renovated for use by the Harris Arts Center, Calhoun-Gordon Arts Council, and the Roland Hayes Museum (for the famous African American tenor born in 1887 near Calhoun). (Courtesy of Gordon County Historical Society.)

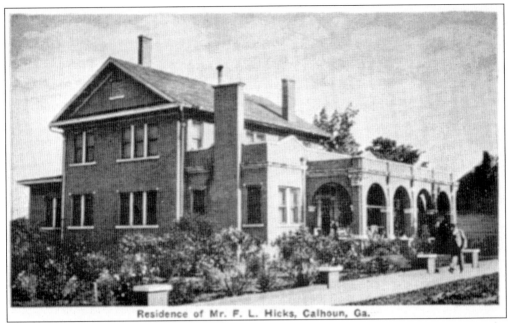

Residence of Mr. F. L. Hicks, Calhoun, Ga.

Fitzhugh Lee Hicks built this grand home on North Wall Street (the Dixie Highway) in 1920. The home has Romanesque (in the arched porch and porte-cochere for the automobile) and Georgian aspects (in the two-story rectangular form of the house with side-gabled roof). Hicks went on to become a mayor of Calhoun in the 1930s. The Hicks home was razed in 1963. (Courtesy of Gordon County Historical Society.)

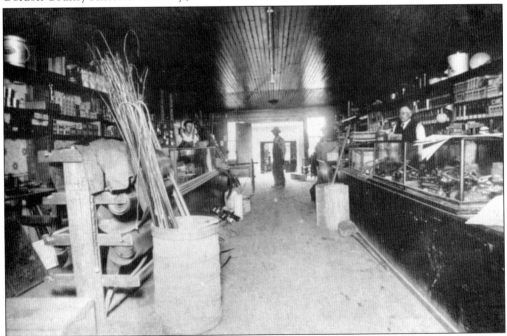

Hicks owned the Hicks-Hughey Supply House located on Wall Street. Hicks (behind the counter on the right) and the store's interior are shown here around 1915. Buggy whips are in the barrel in the left foreground. (Courtesy of Georgia Archives, Vanishing Georgia gor247.)

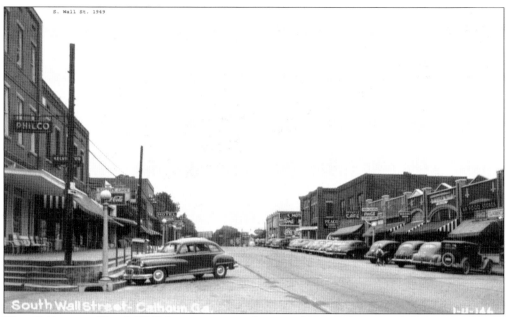

This 1940 view of South Wall Street contains the signs for many businesses the Dixie Highway traveler might frequent: Smith's Café, Hotel Rooker with restaurant, Amoco gas station, Fox Ford motors, Offuts Café (with fried chicken, Coca-Cola, steaks, and chops), Western Union, and A&P Food Stores. (Courtesy of Gordon County Historical Society.)

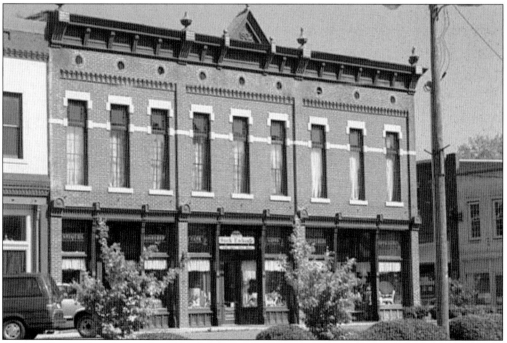

Adairsville was founded in the 1820s by Scottish pioneers, including John Adair, who became a local Cherokee chief. The 1902 Stock Exchange is a restored mercantile building in downtown Adairsville. Both Adairsville and Cassville were bypassed in their entirety in favor of a new Route 41 in the late 1940s. (Courtesy of Georgia's Dixie Highway Association.)

Adairsville is the first town in Georgia to be listed in its entirety on the National Register of Historic Places and includes such historic buildings as the Watts home, pictured here. It was originally a Cherokee cabin, with the Queen Anne additions built in the 1880s. Local lore claims that the Underground Railroad used a subterranean tunnel leading to the house during the War Between the States. (Courtesy of Georgia's Dixie Highway Association.)

The Veach house is typical of the bungalow homes built across the country from the 1920s to 1940s. Most of the structures the tourist saw lining the Dixie Highway in north Georgia resembled this vernacular home. The Veach house now accommodates the Adairsville Inn, which serves fine Southern cuisine. (Courtesy of Georgia's Dixie Highway Association.)

Cassville was created by the Georgia legislature in 1832 as the county seat for the new Cass (now Bartow) County, carved from the original Cherokee territory. By the 1850s, Cassville was the cultural center of north Georgia with two colleges, four hotels, a newspaper, and wooden sidewalks. The city was largely decimated by the War Between the States. The Cassville Post Office was built in the 1880s and was the oldest operating U.S. post office in the state until abandoned in the mid-1990s. Many a Yankee tourist mailed a postcard here. (Courtesy of Georgia's Dixie Highway Association.)

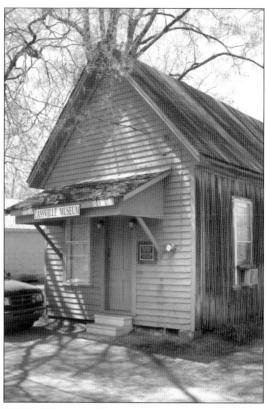

This vintage sign for the Cassville Grocery is a token of the importance of advertising on the Dixie Highway. Buildings were the first billboards, designed to catch the eye of the railroad passenger first and later the automobile tourist. (Courtesy of Georgia's Dixie Highway Association.)

43

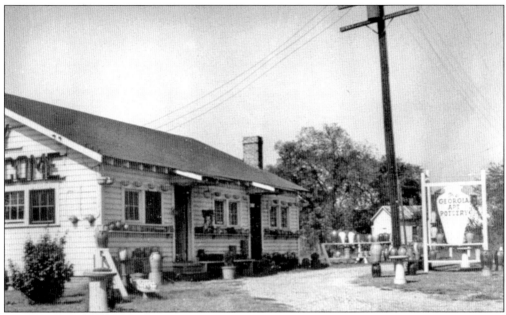

W. J. "Bill" Gordy opened Georgia Art Pottery on the Dixie Highway in 1935. Soon he was selling his jars and vases made of local clay to tourists. His trademark color was a golden brown he referred to as "Mountain Gold," but blue ware was also a specialty. This photograph shows the pottery shop in 1942. This renowned potter's work is displayed in the Smithsonian Museum. (Courtesy of Bartow History Center.)

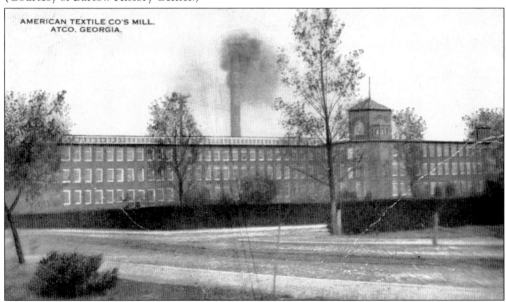

The American Textile Company (ATCO) was founded in 1903 in Cartersville to produce duck cloth for, among other things, canvas tops on Model Ts. The mill village associated with ATCO was considered a model one with varied housing, a library, church, school, barbershop, and store. Goodyear Tire and Rubber Company bought the company in 1929, keeping the ATCO village name but installing a neon advertisement for Goodyear Tire atop the factory. It was open to visitors in the Dixie Highway era. (Courtesy of Bartow History Center.)

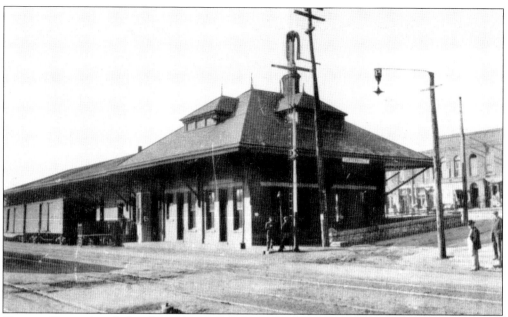

Cartersville was founded in the 1850s with the completion of the Western and Atlantic Railroad. It fared poorly in the War Between the States but rebounded when the county seat was moved here from Cassville in 1868. Development boomed during the 1880s. The original Cartersville Depot now houses the Cartersville–Bartow County Convention and Visitors Bureau. (Courtesy of Georgia's Dixie Highway Association.)

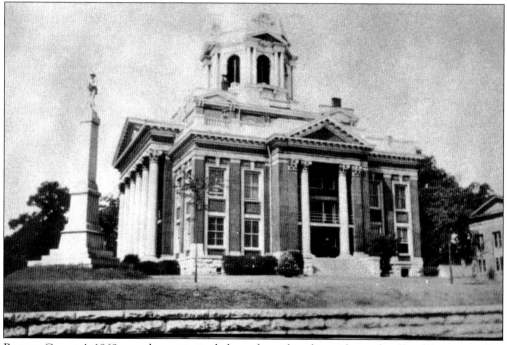

Bartow County's 1869 courthouse is sited along the railroad corridor and suffered from excessive noise from passing trains. The neoclassical 1902 courthouse, pictured here, was built away from the railroad corridor and is in use today. (Courtesy of Bartow History Center.)

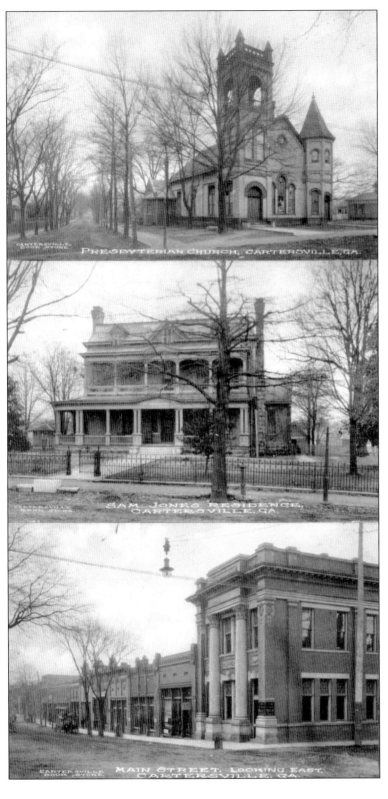

PRESBYTERIAN CHURCH, CARTERSVILLE, GA.

SAM JONES RESIDENCE, CARTERSVILLE, GA.

MAIN STREET, LOOKING EAST, CARTERSVILLE, GA.

This *c.* 1910 triple-scene postcard highlights the First Presbyterian Church, the Sam P. Jones Residence, and Main Street looking east in Cartersville. The First Presbyterian Church was built in 1853 in an Italianate style and is still active at Bartow and Main Streets. Methodist evangelist Sam P. Jones (1847–1906) popularized the adage "The path to hell is paved with good intentions," and one of his converts built Nashville's Grand Ole Opry for him to preach in. When Jones lived in the house pictured in the center of the postcard, "the parlor ceiling was resplendent with clouds and floating angels."[11] The property is a National Register Historic Site and now houses the Roselawn Museum. The bottom photograph looks east along Cartersville's West Main Street. The First National Bank is in the right foreground. Founded in 1889, it merged with the Cartersville National Bank in 1929 to become the Bank of Cartersville. (Courtesy of Larry O. Blair.)

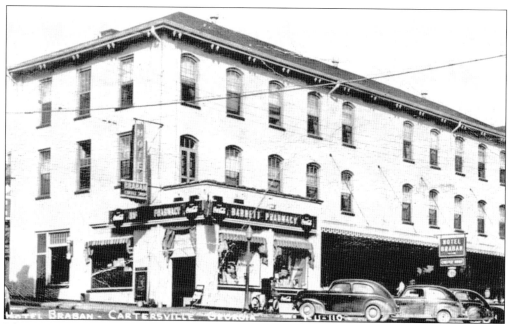

This *c.* 1940 postcard shows the Braban Hotel and Barnett Pharmacy in downtown Cartersville. Local lore has it that the Braban is the original building site for the Imperial Hotel, constructed prior to War Between the States. From its veranda in November 1864, Sherman watched as telegraph lines were cut on his order before he commenced his infamous "March to the Sea." (Courtesy of Bartow History Center.)

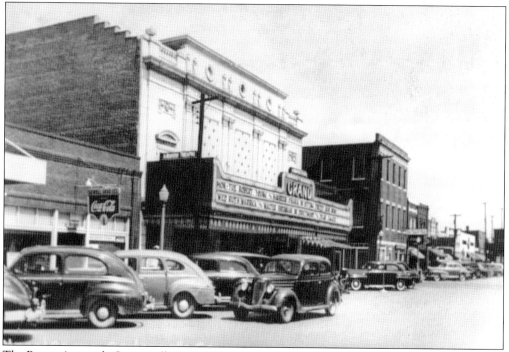

The Beaux-Arts-style Cartersville Grand Theatre was built in 1929 and features a terra-cotta facade. It continues to be the cultural center of Cartersville. (Courtesy of Bartow History Center.)

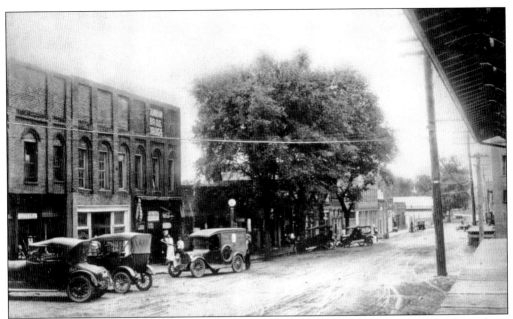

During the Dixie Highway era, Acworth boasted a Victorian downtown, six churches, three cotton/hosiery mills, gas stations, automobile dealers, a tourist court, a diner, a movie theater, and a hotel. The Dixie Highway (Main Street) was paved in July 1926. This photograph, taken from the train depot (eaves at upper right), shows Main Street in the 1920s. (Courtesy of Acworth Historic Preservation Commission [HPC] collection.)

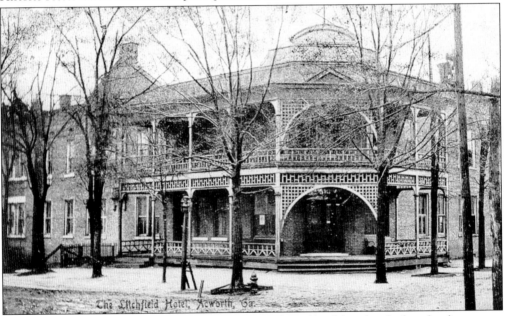

The Litchfield House/Acworth Inn was a two-story, L-shaped brick hotel with chamfered entryway, wide verandas on both stories, and a rooftop cupola at the corner of Main (the Dixie Highway) and Lemon Streets. The hotel was the scene of many group portraits, gatherings, and celebrations for almost a century until the City of Acworth condemned the dilapidated structure in 1961. (Courtesy of Bob Basford.)

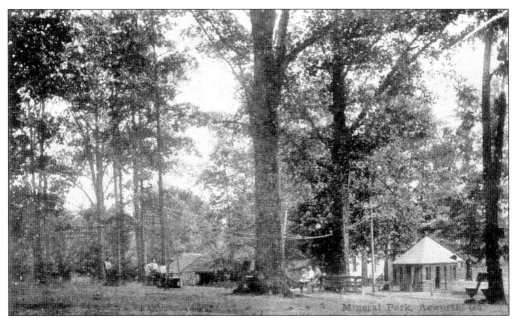

Acworth's Mineral Park, depicted in this vintage postcard, was a regular rest stop for the railroad's travelers en route between Chattanooga and Atlanta. Dixie Highway travelers could still enjoy the tranquil park setting and its healing mineral waters. (Courtesy of Bob Basford.)

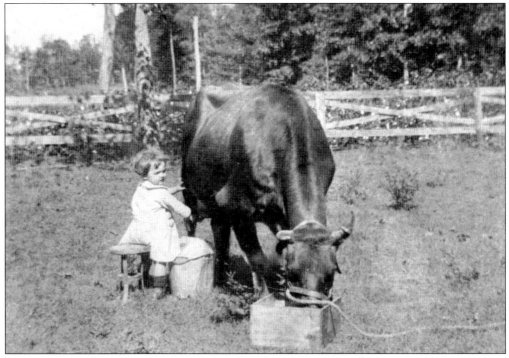

Roy Tippin bred registered Jersey cattle on Rock Dale Farm on the Dixie Highway south of downtown Acworth. He had 35 head of prized pure-bred cattle and a bull. This April 1919 photograph shows his young daughter Ida Louise milking one of her daddy's cows. (Courtesy of Willie B. Kemp.)

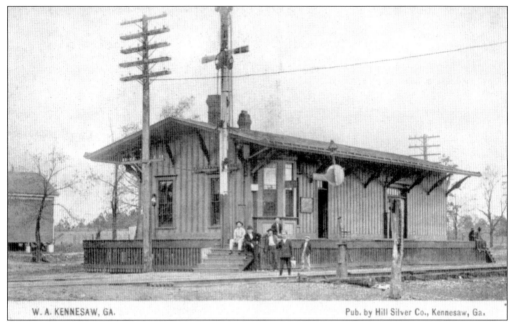

Kennesaw owes its first name, "Big Shanty," to its origin as a construction camp for Irish railroad workers. The town witnessed the commandeering of the locomotive "The General" by Union spies in the Great Locomotive Chase. After the war, the town took the name Kennesaw to commemorate the battle of Kennesaw Mountain. The depot in the vintage postcard here was constructed in 1908 by the Nashville, Chattanooga, and St. Louis Railroad. A renovated depot is now used for special events. (Courtesy of Bob Basford.)

Twenty-two Union spies stole The General from Big Shanty while the passengers and crew ate breakfast at the Lacy Hotel. The raiders were pursued by the crew in the engine "The Texas." The General's engine gave out before Ringgold, and the raiders abandoned it. This early-20th-century photograph shows the site of the Lacy Hotel's replacement, the Kennesaw Railroad House, a hotel and rest stop. The General is currently housed in the Southern Museum of Civil War and Locomotive History in Kennesaw. (Courtesy of Cobb Landmarks and Historical Society.)

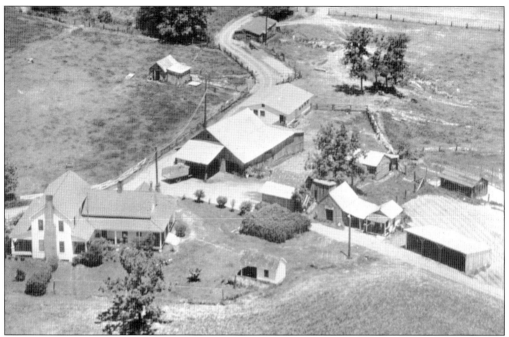

This *c.* 1920 aerial view shows the T. D. Ellison home and farm on the Dixie Highway south of Kennesaw. The original home was purportedly used as a hospital in the War Between the States; Ellison expanded and remodeled it. The farm is now the site of Cobb County Airport–McCollum Field, which opened in 1960. (Courtesy of Joe McTyre.)

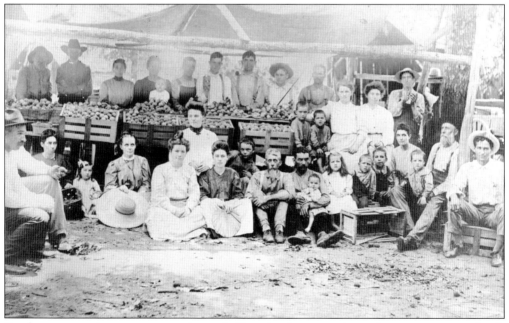

Peaches were not just a crop grown in south Georgia; they were also an important source of cash for families along north Georgia's Dixie Highway. As this *c.* 1910 albumen print illustrates, it took a lot of people to pack peaches when the crop came in on the Sam Mayes farm in Cobb County. (Courtesy of Georgia Archives, Vanishing Georgia cob563.)

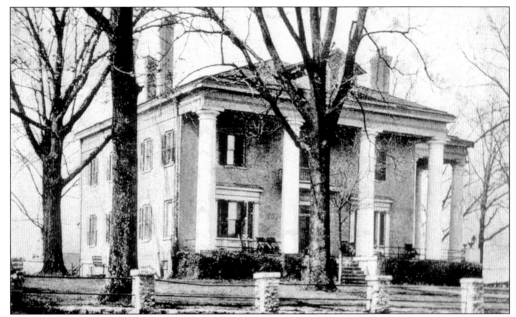

Maj. Archibald Howell built this house in the 1840s. The four front columns are over 11 feet in diameter at the base. Following the War Between the States, the house served as headquarters for Gen. H. W. Judah, a Federal officer who was instrumental in providing food for the starving residents of Marietta. The house still stands on Kennesaw Avenue on the route of the old Dixie Highway. (Courtesy of Marietta History Museum.)

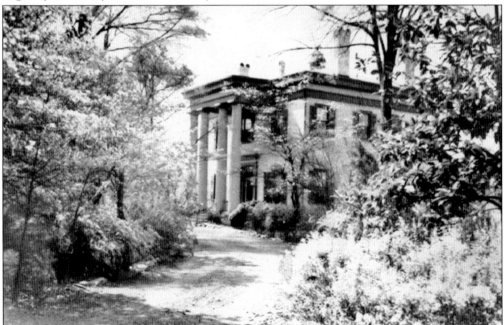

Boston architect Willis Ball designed both the Howell house and Tranquilla, pictured here. It was constructed in 1849, and a kitchen wing was added in 1895. Margaret Mitchell brought designers from the *Gone with the Wind* movie production to study the house for the design of Tara. It is also visible from the Dixie Highway. (Courtesy of Marietta History Museum.)

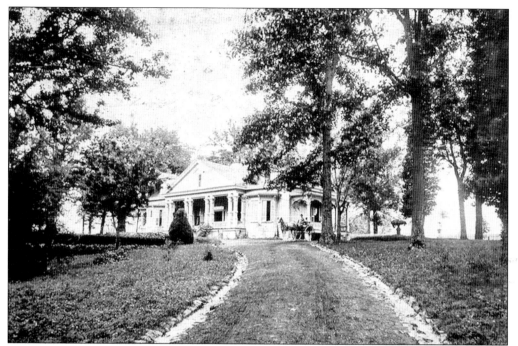

Judge David Irwin built Oakton amid 325 acres in 1838. During the War Between the States, Confederate major general William Wing "Old Buzzard" Loring made Oakton his headquarters because of its commanding view. By the 1890s, John R. Wilder and his family were using Oakton as a summer home; their Scottish gardener planted the formal boxwood gardens that remain today. Oakton's Victorian renovations of the early 20th century covered the original Greek Revival design. (Courtesy of Marietta History Museum.)

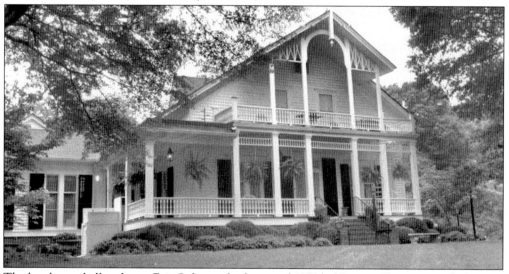

The lovely antebellum home Fair Oaks was built around 1850 by Newton House, an early Georgia educator. The home is reputed to have served during the War Between the States as headquarters for Gen. Joseph E. Johnston during the Battle of Kennesaw Mountain. After the war, it was sold to Mrs. Edward Howell Myers, who named it Fair Oaks. It was remodeled in 1880 to its current chalet/late-Victorian style. (Courtesy of Cobb Landmarks and Historical Society.)

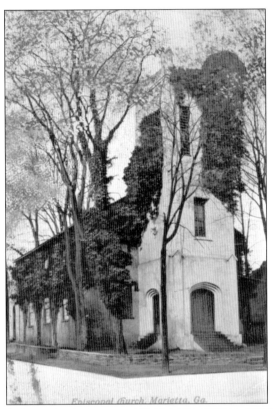

Episcopal Church, Marietta, Ga.

This postcard of the stuccoed brick exterior of St. James Church illustrates the church as Dixie travelers would remember it—with its ivy-covered tower. The Episcopal church was built in 1842 and, like other antebellum churches, served as a hospital for wounded Federal troops. The 1940 *Georgia* guide, written by the Federal Writers' Project, specifically mentions it as a tour stop. It was destroyed by an electrical fire in 1964 and rebuilt as before. (Courtesy of Cobb Landmarks and Historical Society.)

Marietta was still a "cow town" in 1910, as this photograph of Anderson Livery illustrates. In the background is Charles Anderson's livery stable at Whitlock Avenue and the railroad track, just off the Marietta Square. In the foreground, J. T. Anderson Sr. takes the livestock in hand. Note the partial Coca-Cola sign on the wall. (Courtesy of Cobb Landmarks and Historical Society.)

In this 1910 photograph of the west park of the Marietta Square, automobiles are just ascendant but the horse and buggy still reign. (Courtesy of Joe McTyre.)

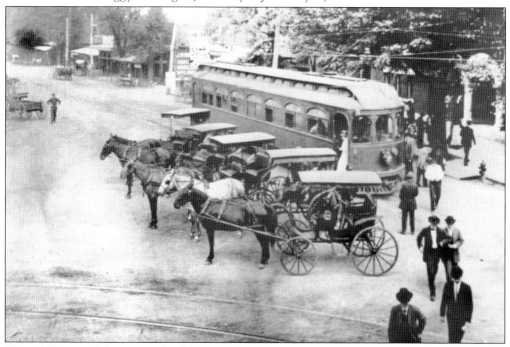

This 1915 view of the east park of the Marietta Square in front of the county courthouse shows a line of horses and buggies ready to pick up disembarking passengers from the electric streetcar from Atlanta. The Atlanta Northern Electric Railway Company streetcar line operated from 1905 to 1947. (Courtesy of Cobb Landmarks and Historical Society.)

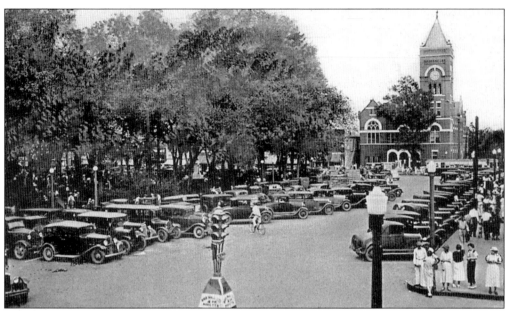

By 1930, the Marietta Square had acquired traffic lights, as seen in the foreground of this photograph. The 1873 Victorian-style Cobb County Courthouse stands in the background. The courthouse was razed in 1966, after a new three-square-block complex of county buildings, including courtrooms, opened on the east side of the square. (Courtesy of Joe McTyre.)

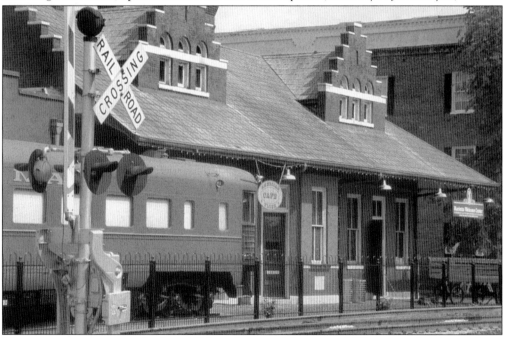

This passenger station was built in 1898 on the site of the original Western and Atlantic depot and served as a passenger depot until the 1950s. Today it is the home of the Marietta Welcome Center and Visitors Bureau. Just beyond the depot on the right is the Kennesaw House. Built in 1845, this former hotel houses the Marietta History Museum. (Courtesy of Georgia's Dixie Highway Association.)

This 1950 view of the Marietta Square looks north toward the Strand Theatre. All of the busy retail establishments on the right side of the photograph (the east side of the square) were razed in the 1960s to make way for new buildings to house the Cobb County courts and offices. (Courtesy of Georgia Archives, Vanishing Georgia cob181.)

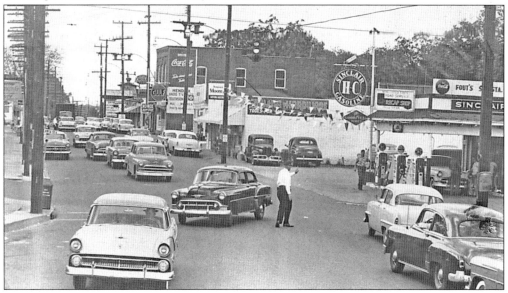

A traffic cop directs cars on the Dixie Highway south of Marietta in the late Dixie Highway era. The area north of Atlanta was a traffic bottleneck for residents and tourists alike. Scenes such as the one in this photograph led to the call for the interstate system to bypass city streets and crossings. (Courtesy of Joe McTyre.)

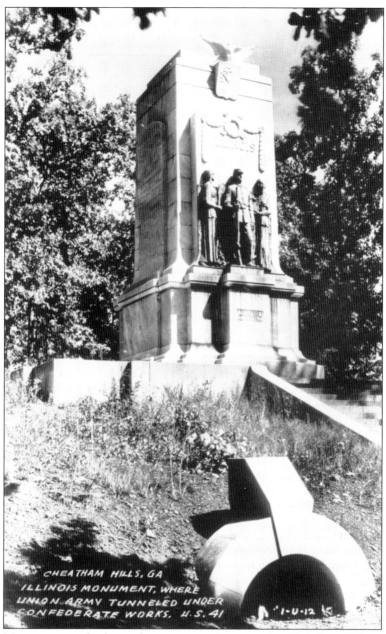

The Illinois Monument was the first such commemoration erected at Cheatham Hill near Kennesaw Mountain. It was placed on the site where Gen. Joseph E. Johnston repulsed Gen. William T. Sherman's attempts to break the Confederate line. The monument was created of white granite by architect James B. Dibelka and sculptor J. Mario Korbel for a cost of $20,000. The Illinois governor, many veterans, and leading Northern citizens were entertained by Marietta citizens at a barbecue and program for the monument's dedication on June 27, 1914, the 50th anniversary of the battle. The inscription on the monument's north face reads, "Erected in memory of the Illinois soldiers who died on the battlefield of Kennesaw Mountain, Georgia June 27, 1864." The marble arch shown in the forefront of this vintage postcard represents the mouth of the tunnel that the Union troops dug under the Confederate fortifications. (Courtesy of Larry O. Blair.)

Three

SEND A POSTCARD

North Georgia had important historic and natural advantages for sightseeing even before the Dixie Highway traversed it. Civil War veterans had lobbied for the establishment of Chickamauga and Chattanooga National Military Park, and the nation's first such protected Civil War site was created in 1890. Veterans also influenced the placement of monuments and historical markers in cemeteries and other battlegrounds such as Kennesaw Mountain National Battlefield Park (which was authorized for federal protection in 1917). In the Depression era, the federal government actively invested in commemoration and preservation of Civil War sites through New Deal programs. Members of the Civilian Conservation Corps (CCC) manned the visitor center at Kennesaw Mountain and served as private guides, driving the tourists in their own cars to points of interest. The Works Progress Administration (WPA) began, and the National Park Service finished, five picnic pavilions along the Dixie Highway highlighting the Atlanta campaign.

The Dixie Highway also crossed the ancestral lands of Native Americans. Another New Deal initiative, the Federal Writers' Project, produced a guidebook for Georgia in 1940 that included directions to Native American sites that were not yet publicly protected. Privately owned Etowah Indian Mounds near Cartersville was just beginning to be explored by archeologists. It gave visitors a glimpse into the ancient Mississippian culture (1000–1500 AD) of the mound builders. They were succeeded in the area first by the Creeks and then by the Cherokees. The Cherokee Nation at its peak stretched from its heart in north Georgia to western Virginia and the Carolinas, eastern Tennessee and Kentucky, and northeast Alabama. In 1931, a granite obelisk was dedicated at the site of New Echota near present-day Calhoun. This capital of the Cherokees established in 1825 was short lived; the State of Georgia seized Cherokee lands and distributed them to white settlers via an 1832 lottery. In 1838–1839, the remaining Cherokees were forced out of their homes and marched to Oklahoma along the Trail of Tears, or "Trail Where We Cried."

Abundant natural scenery could be viewed by Dixie Highway tourists, starting with Lookout Mountain on the Tennessee-Georgia border. Garnet and Frieda Carter created a unique travel attraction at Rock City, and the "See Rock City" barn became a phenomenal advertising campaign. In 1940, the north Georgia Dixie Highway was described as winding through a "green Appalachian Valley where the mountains, though not spectacular, have a calm beauty."[12]

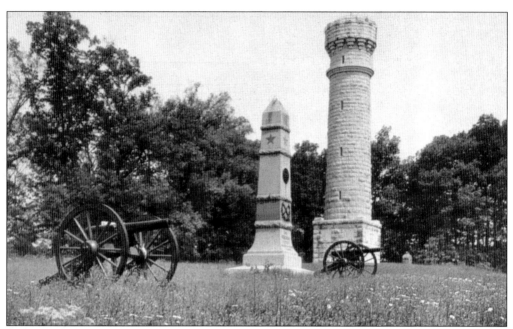

The 85-foot Wilder Brigade Monument at Chickamauga Park honors Union colonel John Wilder and his "Lightning Brigade" of mounted infantry from Illinois and Indiana, who attempted to stave off advancing Confederates. The monument was planned in 1892 to be 105 feet, but economic hard times forced a reduction in the design. The monument was completed in 1899 and houses a viewing platform on top. (Courtesy of Bob Basford.)

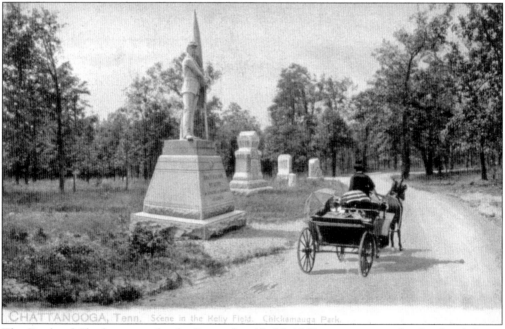

The Battle of Chickamauga, fought September 18–20, 1863, was a victory for the Confederate forces in attempting to halt the Union advance. A carriage wends its way through Kelly Field past commemorative monuments in this postcard from early 1900s. (Courtesy of Bob Basford.)

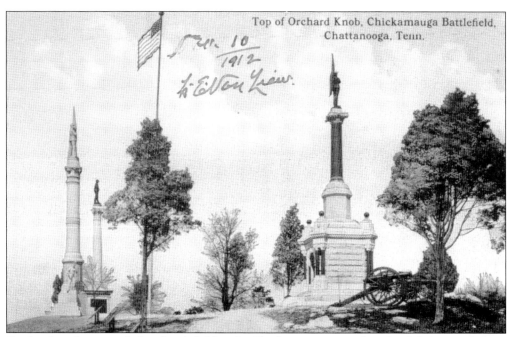

Credited as the nation's first battlefield park, Chickamauga is sited on land that passed three times between Union and Confederate forces. Visitors along the Dixie Highway ventured to nearby battle sites during their travels through north Georgia, including this one at Orchard Knob. (Courtesy of Bob Basford.)

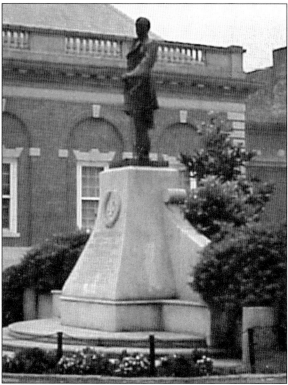

Pictured here in downtown Dalton is the only outdoor statue portraying Confederate general Joseph E. Johnston. Erected in 1912 by the local chapter of the United Daughters of the Confederacy (UDC), the monument honors Johnston, whose series of defensive actions against General Sherman formed the basis of the Atlanta campaign. The bronze statue is 15 feet high on top of a Georgia-granite base. (Courtesy of Georgia's Dixie Highway Association.)

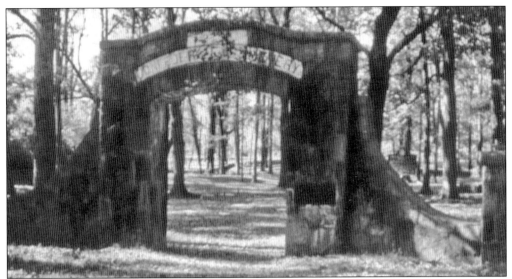

The Confederate Cemetery at Resaca is the oldest such military burial ground in Georgia. After the Battle of Resaca in 1864, Mary J. Green organized the local women to bury the bodies of over 400 Confederate soldiers. The stone-arch cemetery entrance pictured here was erected by the Atlanta Chapter of the UDC in honor of Green. It was made by the Georgia School of Technology and the WPA in the 1930s. (Courtesy of Larry O. Blair.)

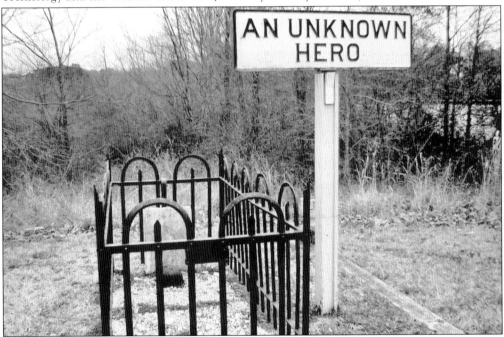

Confederate general John B. Hood moved his army to attack Union general Sherman's supply line and storehouses at Allatoona Pass in the fall of 1864. They found it guarded by a full division of Union troops Sherman had ordered from Rome once he guessed Hood's intentions. Over 5,000 men fought here on October 5 with 1,500 casualties. The battle ended with a Confederate retreat, and an unknown Confederate soldier was entombed here. (Courtesy of Etowah Valley Historical Society.)

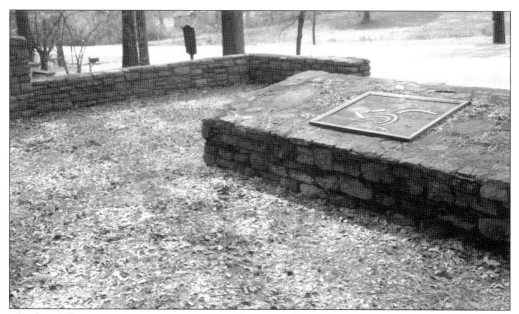

The five Atlanta-campaign interpretive pavilions were begun by the WPA in 1938 and completed by the National Park Service in the 1940s. Each pavilion included picnic tables, a metal interpretive sign on a pole, and a stone wall encircling a stone base with a relief map cast in iron illustrating an event of the campaign. The maps were cast at Georgia Tech, while the stone was quarried locally. This photograph shows the relief map for the Battle of Resaca at the Resaca Interpretive Pavilion. (Courtesy of Georgia's Dixie Highway Association.)

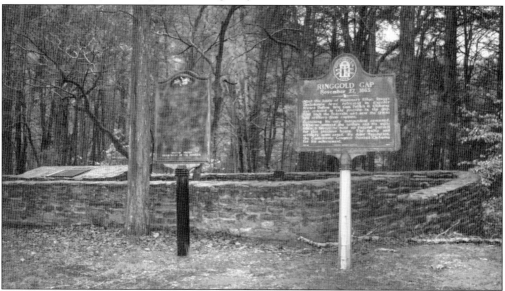

The Ringgold pavilion's map shows the beginning of Sherman's Atlanta campaign at Ringgold Gap. The original Georgia Historical Commission marker erected in the 1950s was stolen; the one shown here is a replacement. Although not in the photograph, twin stone pillars nearby served as an entry to the town of Ringgold. The interpretive pavilions were a roadside respite for travelers; the three others were in Rocky Face, Cassville, and New Hope Church in Paulding County. (Courtesy of Georgia's Dixie Highway Association.)

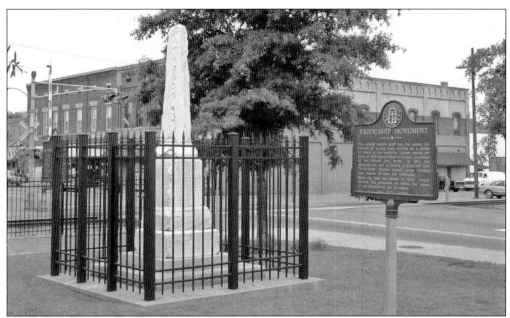

The Friendship Plaza located around the 1850s Cartersville train depot features Mark Cooper's Friendship Monument, the only monument known that was erected by a debtor to his creditors, who stood by him in the financial panic of 1857. The plaza also commemorates numerous notables in Bartow County's history. The monument, erected by Cooper at the town of Etowah in 1860, was moved to Cartersville in 1927. (Courtesy of Georgia's Dixie Highway Association.)

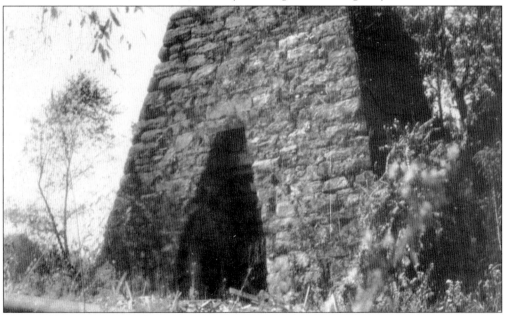

This cold-blast furnace and a chimney at Cooper Iron Works are the only remaining structures from the antebellum town of Etowah. Mark Cooper sold the iron-manufacturing facilities to the Confederacy in 1863, and the Union later destroyed them. In the Dixie Highway era, the site of Etowah was known as an attractive picnic ground before being mostly submerged in the creation of Lake Allatoona in the 1950s. (Courtesy of Kennesaw Mountain National Battlefield Park.)

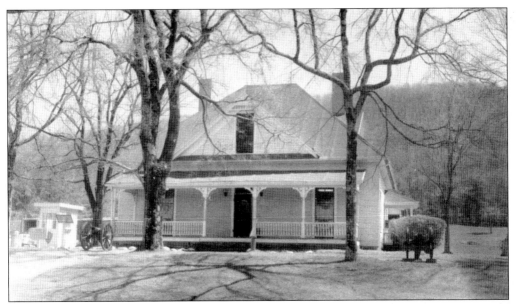

The Kennesaw Mountain National Battlefield Park commemorates the major battles that occurred from June 19 to July 2, 1864. In 1899, a group of Union veterans acquired 60 acres at Cheatham Hill south of Kennesaw Mountain. Cheatham Hill was a private park from 1899 until 1928, when it was deeded to the U.S. War Department. The Hyde home at the foot of Kennesaw Mountain is shown here in the 1920s. (Courtesy of Kennesaw Mountain Battlefield Park.)

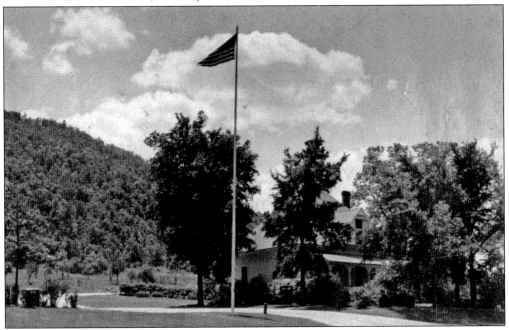

Cheatham Hill was transferred to the National Park Service in 1933, and the Hyde home, shown here in the 1930s, became the headquarters and first visitors' center for the park. It was chosen for its convenient location right on the Dixie Highway. Acquisitions to the park, including Kennesaw Mountain itself and over 2,000 additional acres, continued the next few years. (Courtesy of Kennesaw Mountain National Battlefield Park.)

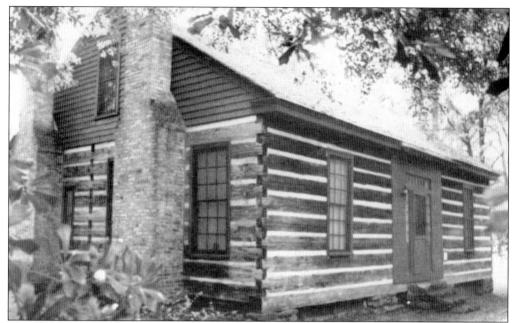

This log home built by Peter Kolb in 1836 stands at the southern end of present-day Kennesaw Mountain National Battlefield Park and was the site of Confederate general John B. Hood's unsuccessful attack on the Union forces on June 22, 1864. The Confederate soldiers were forced to retreat to Cheatham Hill before the Battle of Kennesaw Mountain. (Courtesy of Cobb Landmarks and Historical Society.)

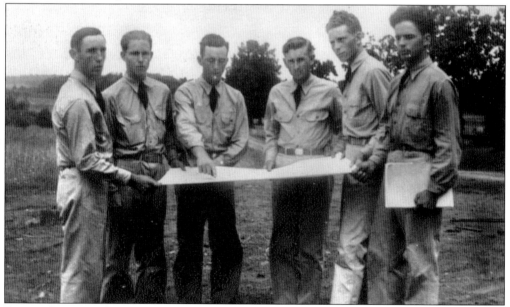

During the 1930s, the Civilian Conservation Corps (CCC) took over management of the park and made many improvements. The CCC workers, some of whom are photographed here in the 1930s, also served as uniformed guides for visitors. The guides were stationed daily at the Hyde home to give escorted tours to Cheatham Hill, even driving the visitors' automobiles for them. (Courtesy of Kennesaw Mountain National Battlefield Park.)

Although Confederate general Johnston repelled Union general Sherman's attack at the Battle of Kennesaw Mountain, he was forced to withdraw from the mountain to defend Atlanta. He was relieved of command before the Siege of Atlanta. The Kennesaw Mountain park was created to protect earthworks, cannon placements, and monuments. This aerial view from Kennesaw Mountain shows one such cannon and the rural landscape below in the 1930s. (Courtesy of Kennesaw Mountain National Battlefield Park.)

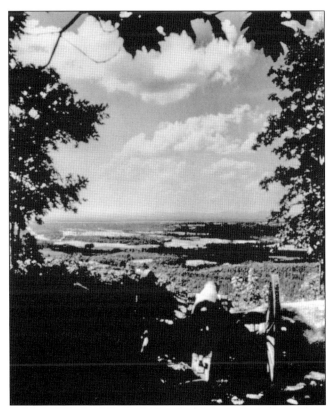

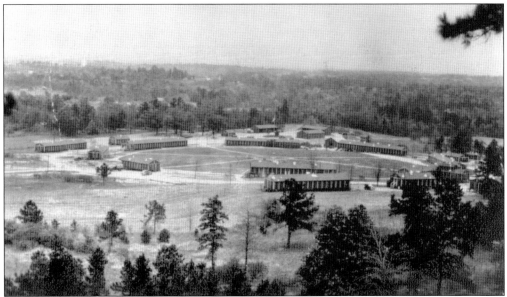

This 1939 aerial view from Kennesaw Mountain shows the CCC Camp No. GA NM-3 for Company 431. The CCC recruits were young men from 18 to 20 years old, and about 250 were stationed at the Kennesaw Mountain camp. In addition to serving as guides, they built trails and restored earthworks. In Georgia, the CCC was segregated; no African Americans worked at Kennesaw Mountain. (Courtesy of Kennesaw Mountain National Battlefield Park.)

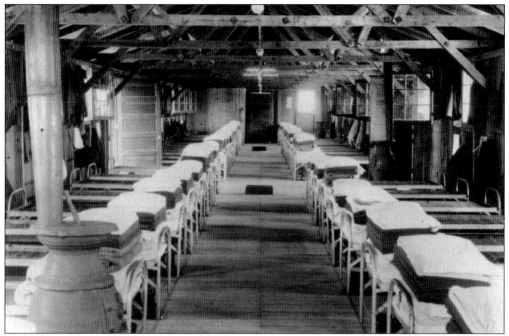

This 1939 photograph shows the interior of the CCC barracks. The young men were given the opportunity for education in addition to their work. Subjects of instruction included literacy, arithmetic, English, history, penmanship, and spelling. Vocational training was available in road construction, soil erosion, woodworking, first aid, and automobile mechanics. (Courtesy of Kennesaw Mountain National Battlefield Park.)

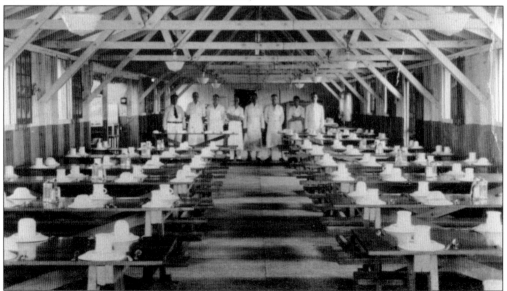

In this 1939 CCC dining hall photograph, the tables are set for the next meal. The CCC received some of its rations from the federal government and some in trade with local Marietta people, including fresh vegetables and eggs. Carless Collins, originally from North Carolina, was trained as a cook in this CCC camp and after his service ran the City Café in Marietta for 31 years. (Courtesy of Kennesaw Mountain National Battlefield Park.)

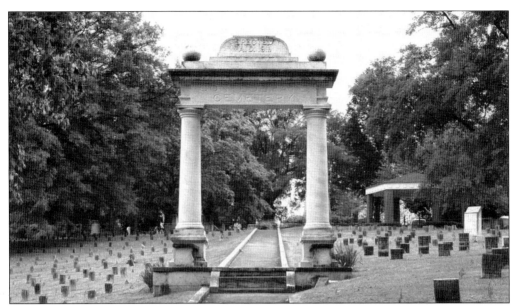

The Confederate Cemetery in Marietta was established in 1864 on land donated from Jane Porter Glover for the burial of about 20 Confederate soldiers who perished in a train wreck nearby. In 1866, the State of Georgia appropriated $3,500 to collect remains of Confederate soldiers from other areas in the state for reburial in Marietta. Wooden markers were replaced in 1902 with plain marble markers. The white marble entrance arch was erected in 1911 facing the Marietta Square. (Courtesy of Joe McTyre.)

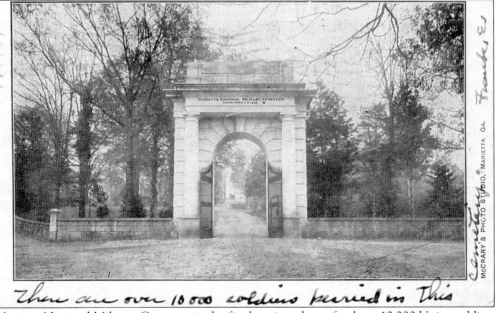

Marietta National Military Cemetery is the final resting place of at least 10,000 Union soldiers from battles across the state. It was established in 1866 on land given by Henry Greene Cole, a Union loyalist whose hopes that both Union and Confederate soldiers would be buried together were not realized. The entry arch was constructed in 1893, and the 23 acres are surrounded by a high stone wall. (Courtesy of Joe McTyre.)

69

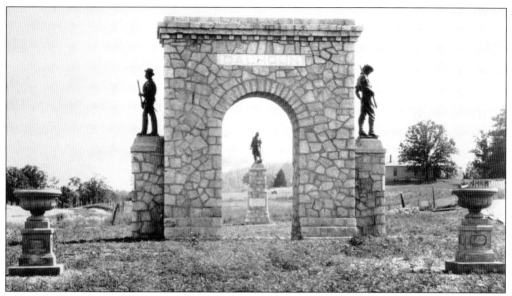

The Calhoun Memorial Arch, photographed here in 1927 by Calhoun Photo Shoppe, was built in native rock at the Calhoun city limits by W. Laurens Hillhouse for the Calhoun Women's Club. Hillhouse also built the stone masonry gate of the Resaca Confederate Cemetery. The bronze statues, manufactured by the J. L. Mott Ironworks of New York, represent a Confederate soldier, a World War I "Doughboy," and the Cherokee leader Sequoyah. (Courtesy of Georgia Archives, Vanishing Georgia gor423.)

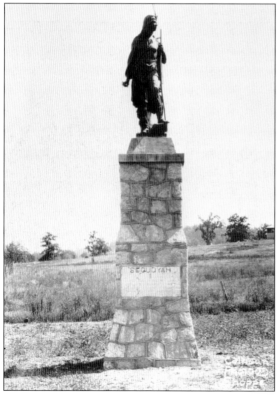

The Sequoyah statue, pictured here in a 1930 photograph by Calhoun Photo Shoppe, honors the creator of the Cherokee alphabet. Sequoyah (1770–1843) devised a system of 85 characters to represent the sounds of the Cherokee language. The Cherokee chiefs approved his work and the printed word was available to their people. Sequoyah went west to Oklahoma with the Cherokees when they were removed from their native lands. (Courtesy of Georgia Archives, Vanishing Georgia gor219.)

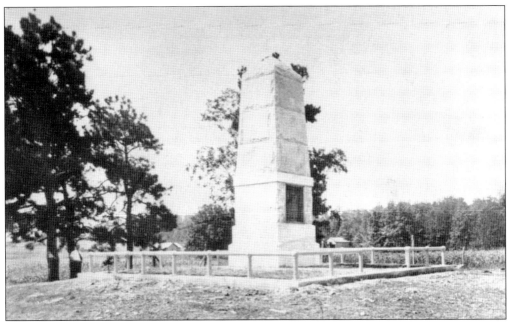

A granite obelisk marks the site of New Echota, the Cherokee capital near Calhoun. The monument was erected in 1931 by the U.S. government. In the Dixie Highway era, most of the buildings were gone, but in 1962, the State of Georgia dedicated a rebuilt New Echota with original and reconstructed examples of the council house, the courthouse, the print shop, and an 1805 store. (Courtesy of Georgia Archives, Vanishing Georgia gor218.)

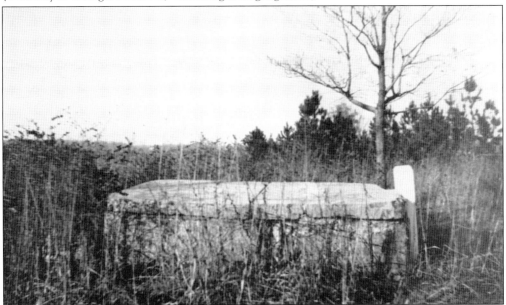

This 1920 photograph is reputed to be of the grave of Chief Pathkiller, the principal leader of the Cherokee Nation until his death in 1827. The cemetery for New Echota also includes the grave of Harriet Gold Boudinot. She was the wife of Elias Boudinot, the editor of the *Cherokee Phoenix*, a New Echota newspaper with articles in both Cherokee and English. (Courtesy of Georgia Archives, Vanishing Georgia gor162.)

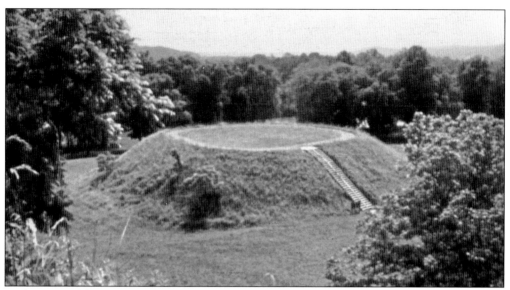

In the prime of the Dixie Highway, the Etowah Indian Mounds were on private property. The 1940 Federal Writers' Project *Georgia* guide directed the tourist to Louis Tumlin's farm and suggested to "ask directions at Tumlin house" to the mounds.[13] The site included six earthen mounds (the largest of which is 63 feet high and covers three acres), a plaza, borrow pits, village, and defensive ditch. The State of Georgia purchased the property in 1953. (Courtesy of Cobb Landmarks and Historical Society.)

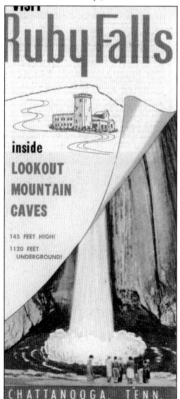

This 1940s vintage brochure promotes the natural wonder of Ruby Falls with its "falls 145 tall and 1140 feet underground." Leo Lambert, a cave enthusiast, developed the Ruby Falls Cave attraction on Lookout Mountain in the early 1930s by offering tours to the public. He named the falls for his wife, Ruby. (Courtesy of Ruby Falls.)

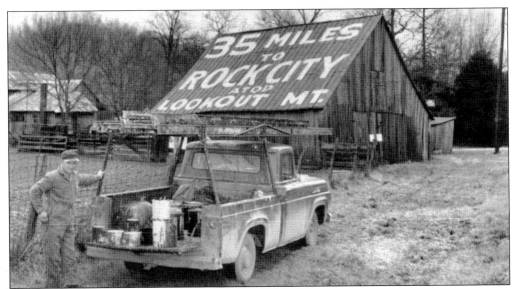

"See Rock City" is a phrase that has been beckoning automobile travelers since 1935. Clark Byers, the official Rock City barn painter, is shown here just after completing a painting. Barn owners were enticed with an offer of a free paint job and Rock City souvenirs in exchange for the slogan on their barns. "See Rock City" would be painted on any structure large enough to be seen from a highway—in time over 900 barns in 19 states. (Courtesy of Rock City.)

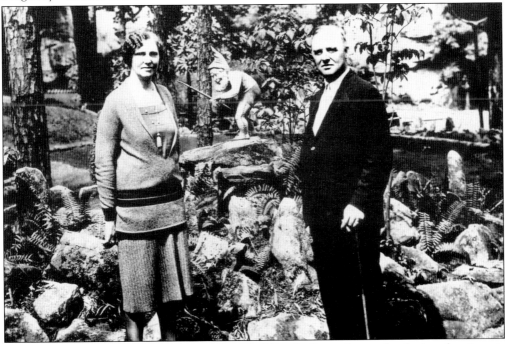

In the midst of the Great Depression, Garnet and Frieda Carter began developing the gigantic rock formations on their property on Lookout Mountain into one of the top tourist attractions in the country. The Carters are pictured here in the Rock City Gardens. In the late 1940s, they added "Fairytale Caverns" with sculptures illuminated by black light to capture the imagination of the smallest tourists. (Courtesy of Rock City.)

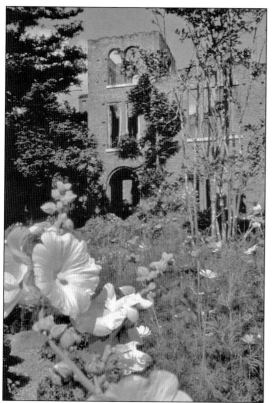

In the 1830s, Godfrey Barnsley, an Englishman living in Savannah, acquired 10,000 acres near Adairsville and began work on a mansion to house his family. His wife, Julia, died before the estate was completed. This modern photograph shows the ruined house. The roof was removed by a tornado in 1906. (Courtesy of Georgia's Dixie Highway Association.)

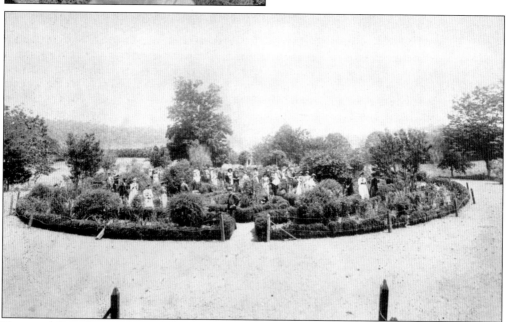

Trees and formal gardens, including a sunken one of English boxwood photographed here, were planted at Barnsley Gardens. By the Dixie Highway era, the mansion was crumbling and the gardens overgrown, but Barnsley was still worthy of a tourist stop. (Courtesy of Georgia Archives, Vanishing Georgia flo095.)

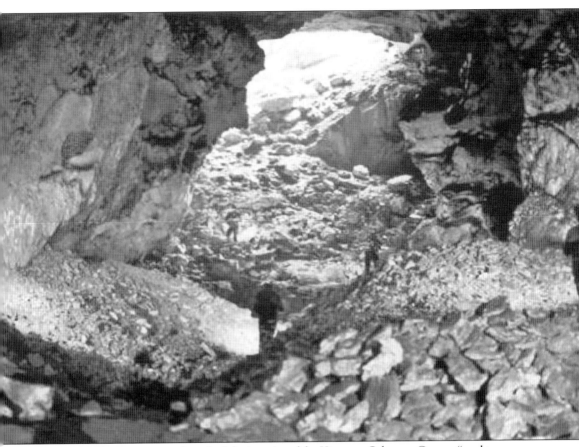

The Dixie Highway magazine described the interior of the Kingston Saltpeter Cave as "a subterranean wonder rivaling Mammoth Cave."[11] During that era, the cave was a commercially developed tourist attraction with an admission of 25¢. Three young local men installed battery-operated lights and a wooden staircase to accommodate the paying public. A dance floor and wagon rides from nearby access points rounded out the rough and rowdy dance-hall environment. Over the years, saltpeter has been used as a meat preservative and a pharmaceutical product. Most importantly, saltpeter is one of three components for black gunpowder. The other two components, charcoal and sulfur, are both abundant in north Georgia. The cave was appropriated by the Confederate army during the War Between the States. The caverns are not currently open to the public but are being maintained and fully studied. (Courtesy of the Kingston Saltpeter Cave Committee of the National Speleological Society.)

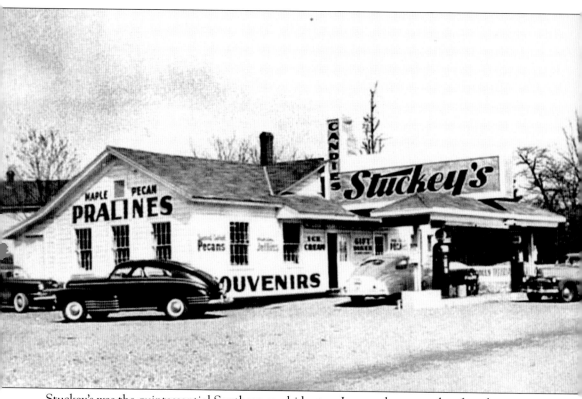

Stuckey's was the quintessential Southern roadside stop. In one place, travelers found souvenirs, candy (pecan log rolls, pralines, fudge, and divinity), ice cream, gasoline, and clean restrooms. W. S. Stuckey started out selling pecans from a roadside stand in south Georgia before World War II; his wife added the homemade candy and the business boomed with tourists.[15] This 1940s postcard depicts one of the early original locations for the Southern chain in Acworth on the Dixie Highway. The Acworth Mills village church is in the right background. The building itself is unremarkable, but the script on Stuckey's sign caught the travelers' attention. This site complied with Stuckey's usual practice of locating on the right-hand side of the highway for the return trip from Florida. Stuckey's found that vacationers on the way home were looser with their money, more likely to lug home souvenirs, and "better prospects for buying unnecessary things like seashell lamps and rubber alligators."[16] With the construction of the new U.S. 41 in the late 1940s, Stuckey's moved out to the "Four Lane." (Courtesy of Acworth HPC collection.)

Four

FILL 'ER UP

The invention of the automobile not only opened the South for exploration by travelers from the North and Midwest, it transformed the culture of the South itself. The early driver needed accessible gas, oil, parts, and mechanics in order to tour successfully by car. Gas was first sold by the bucket, but the invention of the pump greatly simplified refueling. The filling station was usually just a single pump outside a store selling other items. By the 1920s, the service station provided the traveler with gasoline and motor oil, tires, batteries, standardized parts, and qualified mechanics. At first, service stations sold several brands of gasoline under one roof; later brands were housed at distinct stations. Free road maps marked with chain stations were distributed to foster loyalty.

Early travelers who could not count on or afford hotel accommodations carried their supplies with them. These "tin can" tourists had to fit tents, cots, suitcases, stoves, and rations in their none-too-spacious automobiles. They cooked their canned goods and camped wherever they could find an open space. Towns eager for tourist dollars soon opened picnic and campgrounds. Charges were free or nominal. Calhoun opened Pine Grove Camp on the Gordon County fairgrounds in 1921 as a free camping ground; tourist interests were safeguarded by prohibiting "Gypsies and Horsetraders." In the 1920s, travelers had additional options in cabin camps or in tourist homes with a private room let for the night. Cabin camps, tourist courts, or motor courts consisted of tiny cottages usually arranged in a semicircle drive. By the 1930s, the motor court had evolved into the motel—a hotel with a parking space right outside the door to a private room. After World War II, motels inundated the landscape.

Hunger was assuaged in countless restaurants, diners, cafés, and hot-dog stands, with an introduction to Southern cuisine. The gasoline, lodging, and eating establishments used modern architecture and large road signs to grab the attention of the high-speed automobile traveler. Regional and then national chains developed the same building design for all their outlets. Eventually the South's roadside architecture was indistinguishable from other parts of the country.

Those communities lucky enough to be along a major thoroughfare took their "identity and economic existence from the highway."[17] The inhabitants became less insular through interaction with non-natives and neighboring residents, and through the opportunity for increased mobility. During hard times, residents took advantage of that mobility to relocate to Atlanta for jobs. African Americans left the segregated South in droves for jobs in the industrialized North. The highway made possible and accelerated these changes.

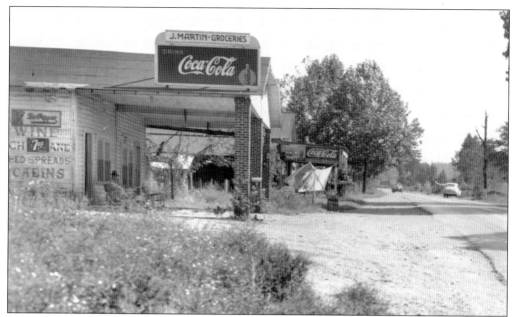

Grocery stores and livery stables were the first establishments to sell gasoline and motor oil. Often they would sell more than one brand of gasoline. J. Martins Groceries was built between 1910 and 1920. It was located two miles south of Adairsville on the Dixie Highway. Owned by James Martin, the building carried advertisements for Coca-Cola, 7UP, and Dr. Pepper, as well as for its associated bedspread and tourist-cabin businesses. (Courtesy of Bartow History Center.)

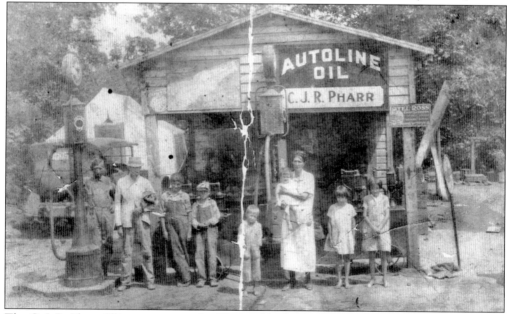

The C. J. R. Pharr filling station south of Ringgold advertised Autoline Oil and the Hotel Ross in Chattanooga, but the brand of gasoline it sold is not readily apparent. Posing for this 1928 photograph are, from left to right, family members C. J. Pharr; unidentified; Howard Pharr; Burgess Pharr; unidentified boy; May Pharr, holding son J. C.; Lottie Pharr Pierce; and Thelma Pharr. The Pharr Station was in operation from 1919 to 1935. (Courtesy of Bradley Putnam.)

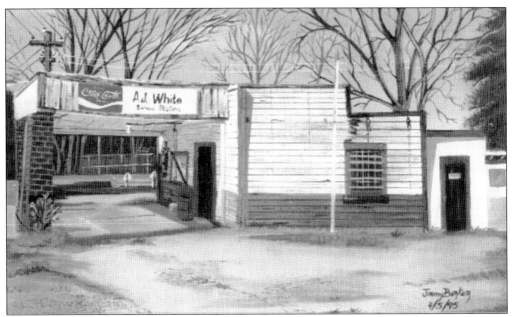

The first street-side gasoline pumps caused traffic backups as cars waited to refuel. The drive-in gas station solved that problem. Grogan's Service Station, a 1920s clapboard drive-through structure on the Dixie Highway in Acworth, served as the refueling station for the Grogan's Tourist Cottages across the street. The painting reprinted here depicts the renamed A. J. White Service Station as it looked in the late 1990s. (Original artwork courtesy of Jimmy Barker.)

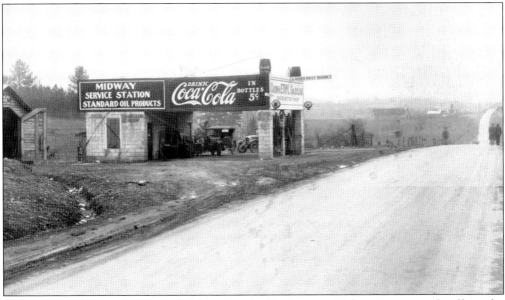

Built between 1915 and 1925, the Midway Service Station near Dalton is an example of how the building became the sign. Like a movie-theater marquee, the roof signboards advertise Standard Oil products, Coca-Cola (5¢ bottles), and Crown Ethyl Gasoline ("Knocks out that knock"). In an acknowledgement that the traveling man was usually bringing his family, the sign jutting from the roof at a right angle simply reads, "Ladies Rest Room." (Courtesy of Georgia Archives, Vanishing Georgia wtf320.)

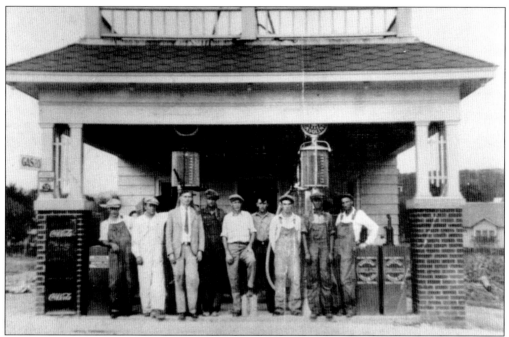

The Tunnel Hill Sinclair was located at the intersection of Oak Street and the Dixie Highway in Tunnel Hill in the late 1920s. Avery Hunt, who lived nearby, is standing second from the left in coveralls. Now the filling station name is associated with a specific gasoline brand. In design, the station resembles a small bungalow house with brick piers (and picket-fence detailing), a low-pitched roof, and a parapet. (Courtesy of Bradley Putnam.)

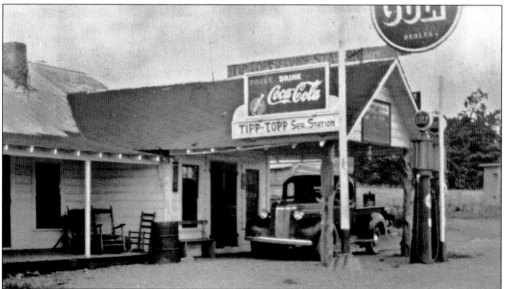

The Tipp-Topp Service Station was owned and operated by Tilman Orville Manning and his son J. D. during the 1930s and 1940s on the Dixie Highway at the very top (hence the name) of Cassville Mountain. It was a Gulf dealer, with the familiar circular orange sign with blue lettering. As with the Tunnel Hill Sinclair, the station's design looked like a small house, complete with rocking chairs on the porch. (Courtesy of Ronald Manning.)

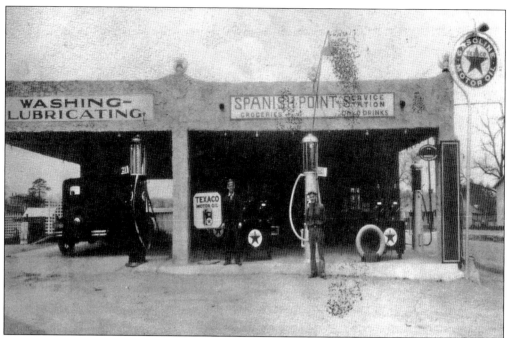

Dewitt Storey (left) and Winfred Hayes (right) stand at the ready in 1930 at the Spanish Point Service Station in Ringgold on Nashville Street. It was a Texaco affiliate (with its familiar star brand) that offered washing and lubricating for automobiles, as well as groceries and cold drinks. This station operated until the late 1980s. (Courtesy of Bradley Putnam.)

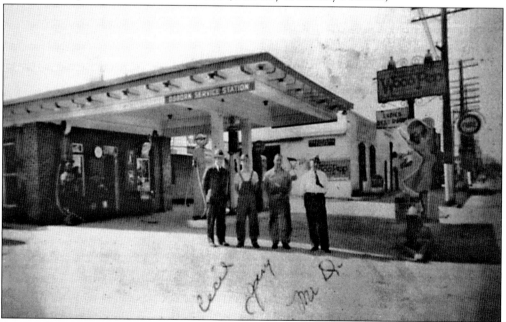

D. C. Osborn, far right, operated this full-service station in downtown Smyrna south of Marietta on the Dixie Highway until the 1950s. Note the cantilevered canopy with exposed rafters. The Osborn Service Station carried Woco-Pep gasoline, whose slogan was "Are you Woco-mobiling? Woco-Pep Makes More Miles, Less Carbon." (Courtesy of Joe McTyre.)

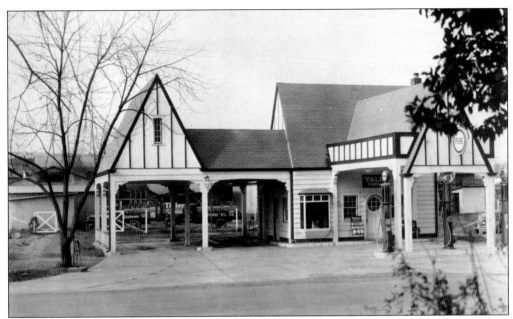

Beginning in 1927, the Pure Oil chain erected distinctive stations with a picturesque white English-cottage motif designed by self-taught architect Carl Petersen. The stations were white with blue trim and blue porcelain enamel-tile roofs. They were meant to invoke domesticity and safety. The Pure Oil Station in Dalton was photographed in 1937 for this postcard by Finley's Studio in Dalton. Note the clapboard siding and an open service bay on the left. (Courtesy of Georgia Archives, Vanishing Georgia wtf334.)

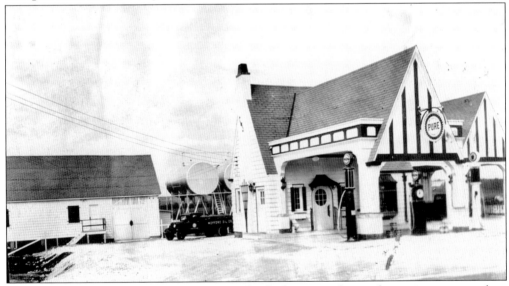

Although service stations would still have individual owners, the gasoline companies sought a standardized, recognizable style for the traveling public. No company did this as well as the Pure Oil Company, including this one in Calhoun. Note the trellis on the chimney, the decorative iron work, and the bracketed pediment over the door. Other examples along the Dixie Highway in Cartersville and Acworth are also still in use or adaptive reuse. (Courtesy of Georgia's Dixie Highway Association.)

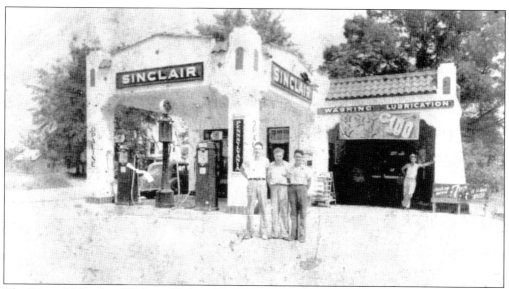

The Ringgold Sinclair Wash and Lube, photographed here in late 1930s, was rendered in mission-style architecture, with a tile roof, square piers and supports, stuccoed walls, and faux bell towers. It was operated by one of Ringgold's characters, Earl Peters, who also owned a restaurant called the "No Dry Zone." (Courtesy of Bradley Putnam.)

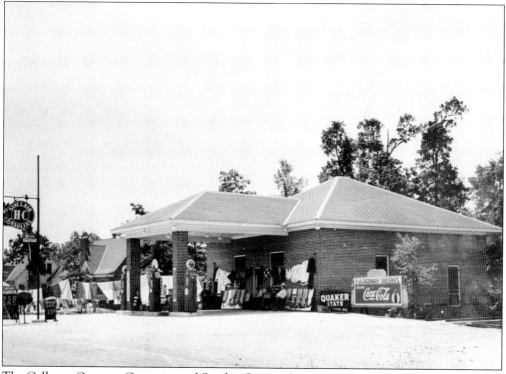

The Calhoun Gazaway Groceries and Sinclair Service Station was built on South Wall Street in 1939. Its design mimicked the hipped roof brick bungalows seen in the background of this 1940s photograph. Its enterprising owner offered chenille bedspreads for sale along with gas at 20¢ a gallon. (Courtesy of Georgia Archives, Vanishing Georgia gor029.)

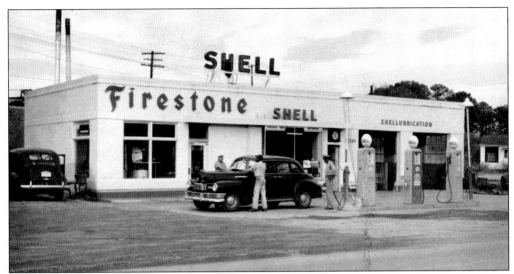

The 1942 downtown Acworth Shell Station represents the design change from tidy cottage filling stations to oblong box full-service gas stations. By the mid-1930s, the full-service station was comprised of repair bays, offices, restrooms, and floor space for selling tires, motor oil, and other accessories. Providing the gas pumping and window washing here are, from left to right, owner Ed Fowler, Claude Hardin, and Harold Davis. (Courtesy of Shirley Fowler Walker.)

While the Acworth Shell is a vernacular International-style service station, the Dalton Shell (photographed here at night about 1950) is a corporate design. The image is sleek and utilitarian with International style (flat roofs, smooth wall surfaces, and windows flush with outer walls) softened with Streamline Moderne rounded corners. The attached canopy is dispensed with here, eliminating columns that could be a traffic hazard. (Courtesy of Georgia Archives, Vanishing Georgia wtf171.)

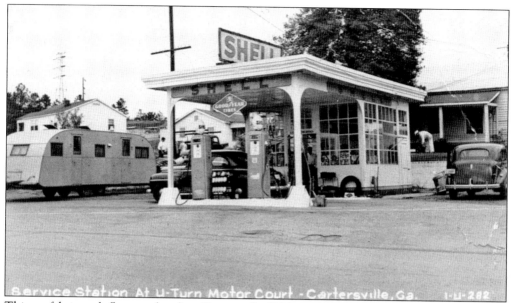

Service Station At U-Turn Motor Court - Cartersville, Ga. 1-U-282

This prefabricated, flattop, glass-box Cartersville U-Turn Shell served customers of the U-Turn Motor Court, visible on page 98. Prefabricated buildings could be set up in a day or two and easily moved. They were produced by independent companies and available for purchase by anyone wanting to open a gas station. (Courtesy of Georgia's Dixie Highway Association.)

Gus Coleman is behind the wheel of a Hupp Special owned by Harris Robinson in this *c.* 1922 photograph taken in Cobb County. Coleman was the unofficial champion of black race-car drivers at this time in the South. (Courtesy of Georgia Archives, Vanishing Georgia cob276.)

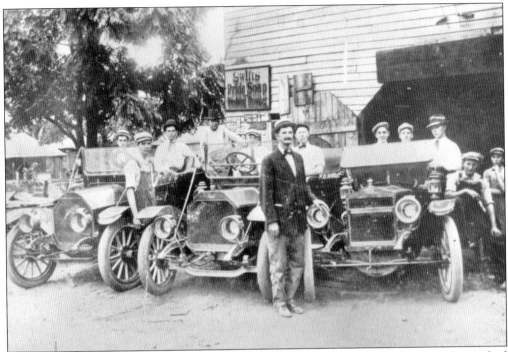

In the first two decades of the 20th century, garages not only repaired vehicles, they also washed and stored cars for overnight or longer time periods. This garage photographed in 1920 is alleged to have been the first in Calhoun. It was located near the first Rooker Hotel and would have sheltered cars for the hotel's guests. The automobiles are, from left to right, a Mitchell, a Buick, and a Maxwell. (Courtesy of Georgia Archives, Vanishing Georgia gor406.)

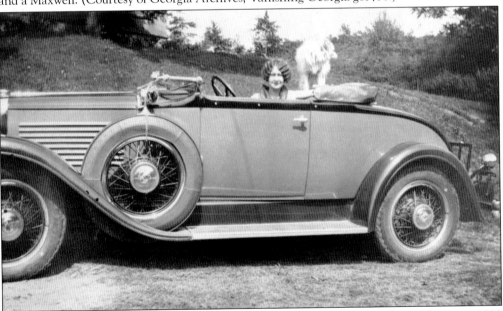

Edna Boston and her pooch enjoy a drive in a Nash Roadster complete with rumble seat in 1929 Calhoun. Boston's stylish shingle-bobbed hairdo matched the streamlined shape of the Nash. (Courtesy of Gordon County Historical Society.)

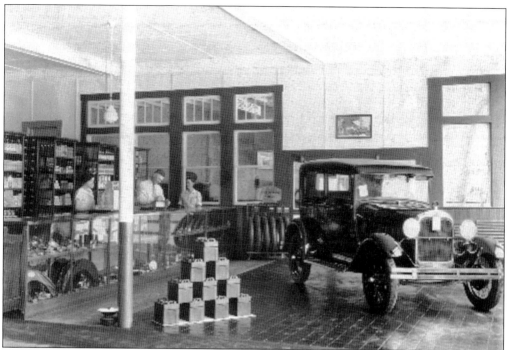

The J. C. Fox Garage Company of Calhoun advertised "Storage" and "Everything for your Car" in a 1918 issue of *The Dixie Highway* magazine. By the late 1920s, the Fox Motor Company was a Ford Dealership in a grand two-story building on South Wall Street. Note the Ford Victoria and the pyramid of batteries on display in this 1929 interior photograph. James Carl Fox is behind the counter in the middle. (Courtesy of Gordon County Historical Society.)

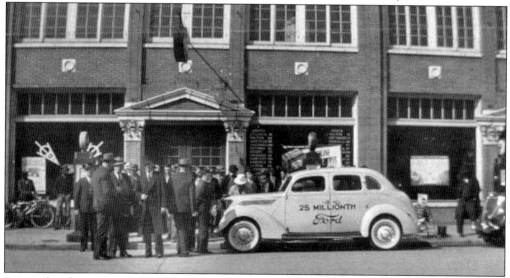

A crowd gathers around the 25th-million Ford automobile manufactured in the United States in 1937. The car was taken on a driving tour around the country. It is parked outside the Fox Motor Company. The Fox building looked like a hotel or office, but it was a showroom for both automobiles and parts with large plate-glass windows for the displays. It would have had a freight elevator to access the second story. (Courtesy of Gordon County Historical Society.)

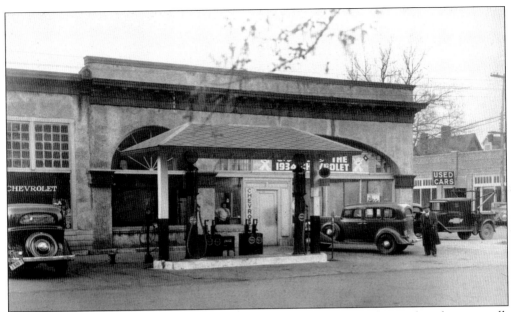

Hardwick Chevrolet in Dalton sold not only new vehicles but sold gasoline and used cars as well. Like the Fox Motor Company, it was housed in a large-scale, prestigious building. The dealership sold Woco-Pep and another brand of gasoline. Dorothy Cox is inside the building, and Mack Hardwick is at the far right in this 1934 photograph. (Courtesy of Georgia Archives, Vanishing Georgia wtf303.)

Lemon Motor Company was located at the corner of Main and Smith Streets in the 1940s, across the Dixie Highway from the Greyhound bus station and across Smith Street from the Pure Oil gas station. It was a Desoto dealership with Gulf gasoline pumps out front. Unlike the impressive car dealership buildings of the 1920s and 1930s, the post–World War II automotive showrooms were of a smaller scale in modern, utilitarian buildings. (Courtesy of Acworth Society for Historic Preservation.)

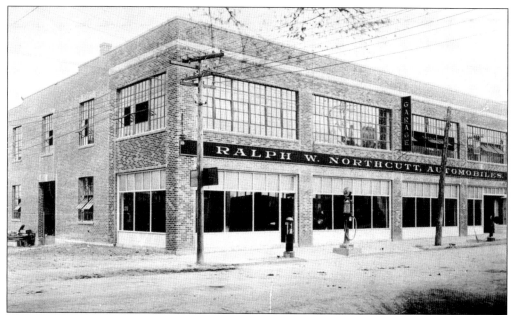

The Ralph Northcutt Automobile Dealership in Marietta also served as a garage and a filling station in 1925. Note the curbside gravity-fed pump and the air compressor. In a two-story automobile showroom on a major touring route such as this one, dealers often provided lockers and showers for chauffeurs, just as livery stable owners had done for coachmen.[18] (Courtesy of Georgia Archives, Vanishing Georgia cob303.)

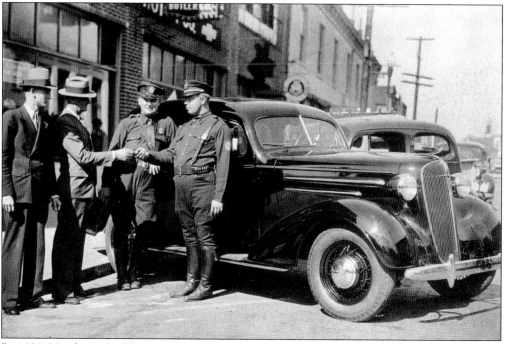

By 1930, Northcutt had become Anderson Motor Company at the same premises. In this early 1930s photograph, owner James T. Anderson Sr. hands the keys to a new Chevrolet to police officer James E. Williams. (Courtesy of Georgia Archives, Vanishing Georgia cob403.)

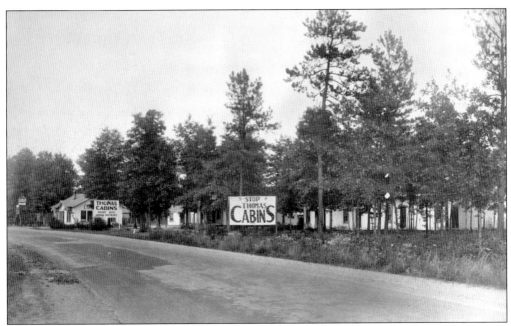

Thomas Cabins was a very early tourist court in Whitfield County. The office was a private house with Gulf gasoline offered in the pump outside. A series of signs was used to lure in the traveler, with the first reading "Stop Thomas Cabins" and the second advertising "Private Bath" and "Simmons Mattresses." The early clapboard cottages are free standing. Finley's Studio of Dalton photographed the site for this postcard. (Courtesy of Georgia Archives, Vanishing Georgia wtf321.)

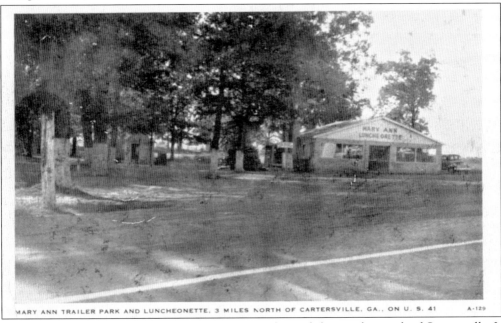

MARY ANN TRAILER PARK AND LUNCHEONETTE, 3 MILES NORTH OF CARTERSVILLE, GA., ON U. S. 41 A-129

The Mary Ann Trailer Park and Luncheonette was located three miles north of Cartersville. It featured tiny cabins as well as a space to park a car and trailer. Early cabin interiors would have been very sparse with a bed and a table or nightstand. (Courtesy of Bartow History Center.)

90

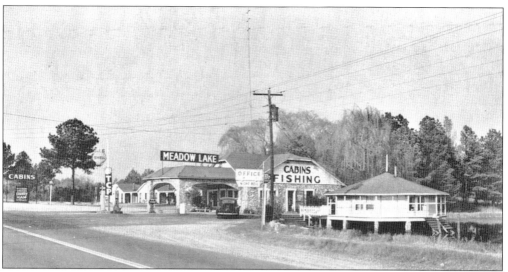

The Meadow Lake Cabins in Tunnel Hill promised cabins and fishing in large, eye-catching letters. Travelers stayed in tourist cabins along the lake and gassed up at the Shell pumps. The office with its unusual roof is still along the old Dixie Highway but the porte-cochere has been filled in. (Courtesy of Georgia's Dixie Highway Association.)

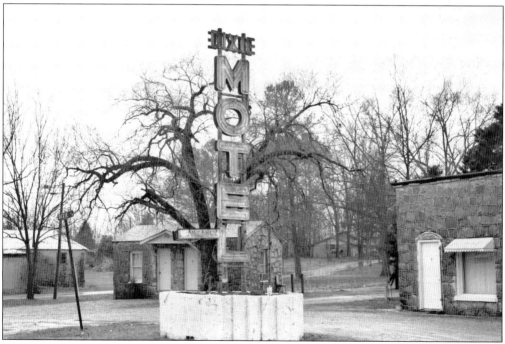

The Dixie Motel in Ringgold is a pre–World War II set of fieldstone duplex cabins that was perhaps renamed "motel" to have a more modern appeal. The vertical neon sign would have caught the tourist's attention, and the name "Dixie" would have linked it to the highway and Southern heritage. (Courtesy of Jeffrey L. Durbin.)

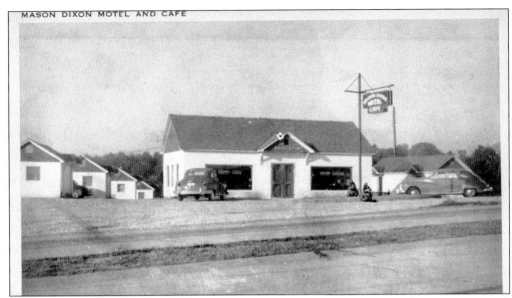

The Mason-Dixon Motel and Café also features detached cabins, as seen in this 1940s postcard. Like the Dixie Motel, its name invokes the old South, but it is more of an intermediary tourist court than a modern motel. The Mason-Dixon's cabins had clapboard siding and gabled roofs that invoked images of home and domesticity. The motel was located at the end of the two-lane Dixie Highway, before the start of the new "Four-Lane" completed in the 1940s in Cobb County. (Courtesy of Joe McTyre.)

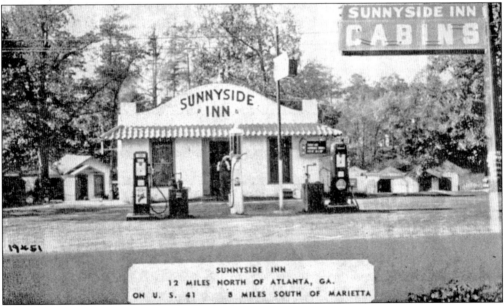

The Sunnyside Inn Cabins south of Marietta were built in the 1920s and decorated with Civil War memorabilia. The owners advertised, "each cottage with private shower bath, hot and cold water, and private garage." While the cabins look like domestic cottages, the office has a mission-style roof parapet and porch projection. In most tourist-cabin establishments, the largest building would be the focal point and contain the office and living quarters of the owner. (Courtesy of Bob Basford.)

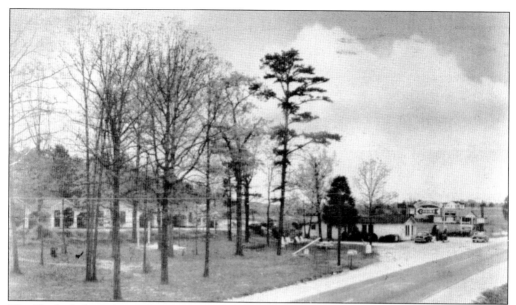

The Shady Oaks Cabins offered "modern heated cabins—Reasonable rates—Friendly service—Good food—Standard gasoline" just 12 miles south of Chattanooga in Ringgold. The cabins were actually connected with a carport in between. The cabins also offered families a respite with Adirondack chairs, picnic tables, and a seesaw near the office. (Courtesy of Bob Basford.)

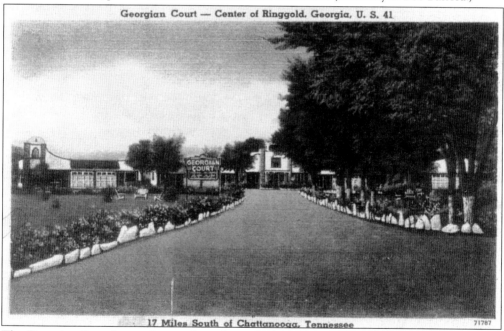

Georgian Court — Center of Ringgold, Georgia, U. S. 41

17 Miles South of Chattanooga, Tennessee

The Georgian Court boasted steam-heated attached cottages with tubs and showers and locked garages. The color postcard here shows extensive landscaping with grass lawns, flower beds, rock borders, painted tree trunks, Adirondack chairs and benches, and red doors on the entrances to the cottages—all to get the travelers' attention and compel an overnight visit. Unlike most tourist courts located on the outskirts of towns, this one was right in the center of Ringgold. (Courtesy of Bradley Putnam.)

STONEWALL COTTAGES
E. R. ANDERSON R. F. D. NO. 1 SMYRNA, GA.

The Stonewall Cottages were also connected, in this case by carports with balustrade parapets. They were clapboard cottages located south of Marietta with a name intended to invoke Southern history and tradition. All of the accommodations along the Dixie Highway in north Georgia were strictly segregated; no African Americans would have been allowed to stay at any of the tourist courts, cottages, or motels featured in this book. (Courtesy of Larry Blair.)

Camp Elms on U. S. 41, Adairsville, Ga.

Camp Elms in Adairsville (as seen in this 1940s postcard in color) included modern tourist cottages, a restaurant, and a Texaco gas station. The cottages were connected with a dual carport in between each duplex. Oftentimes on the Dixie Highway, existing gas stations or private homes were upgraded with new facades, and cabins were added to create the tourist court. (Courtesy of Bartow History Center.)

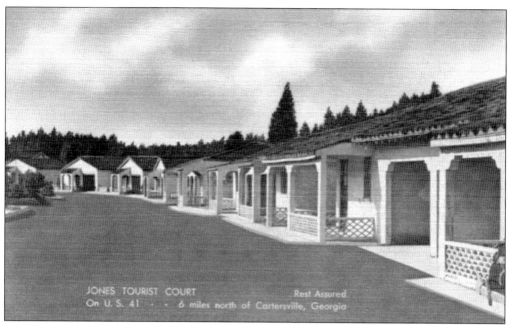

"Rest assured" is what the Jones Tourist Court promised in its location on the Dixie Highway six miles north of Cartersville. This c. 1945 color postcard shows the unique orange terra-cotta roofs, front individual courtyards with latticework boundaries, attached cottages, and carports. (Courtesy of Bartow History Center.)

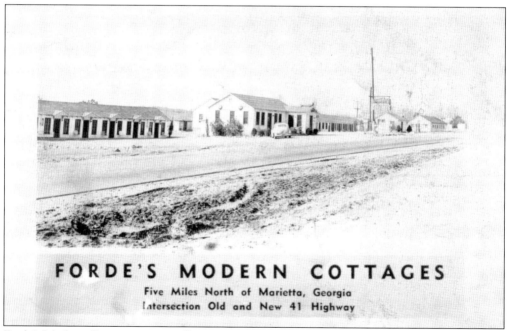

Forde's Modern Cottages were really connected rooms paralleling the Dixie Highway north of Marietta at the intersection of Old and New Highway 41 after the new "Four-Lane" was built. This 1940s postcard shows the evolution from cottages to the modern motel. (Courtesy of Bob Basford.)

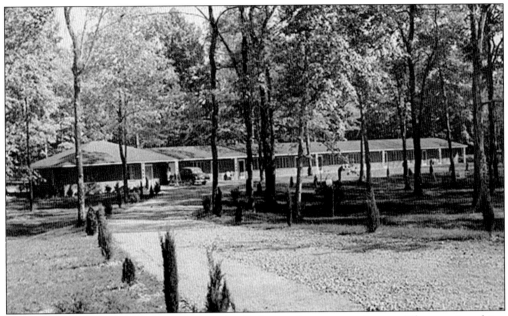

The Dalton Motel was built in 1951 with all the modern conveniences. The curving drive directed the tourist through the landscaped lawn and trees to the rooms. Unlike at a hotel, the car could then be parked right outside the door of the guest's room. (Courtesy of Georgia Archives, Vanishing Georgia wtf175.)

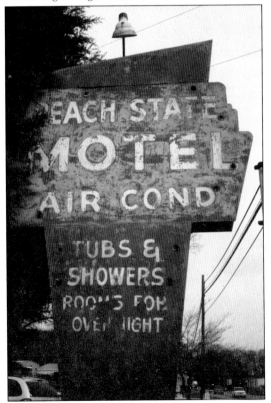

The Peach State Motel, with its exaggerated modern vertical sign, advertised air-conditioning, tubs and showers, and rooms for overnight. The low building with connected rooms was located just south of Dalton. (Courtesy of Georgia's Dixie Highway Association.)

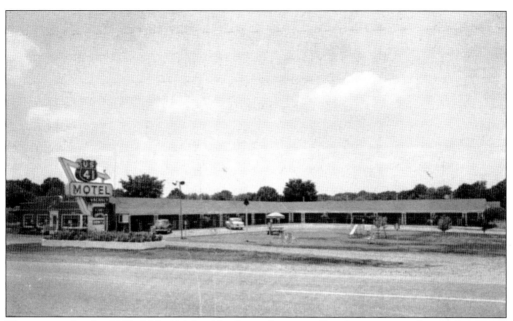

The setting for the 1950s U.S. 41 Motel looks stark, especially when compared with the tourist court accommodations above that were set in shady groves for privacy and quiet. The exaggerated modern sign with oversized highway shield and triangular arrow directed tourists to a modern utilitarian building. The doors of the rooms can barely be seen under the roof overhang. A playground and a picnic area occupy the front lawn. (Courtesy of Bartow History Center.)

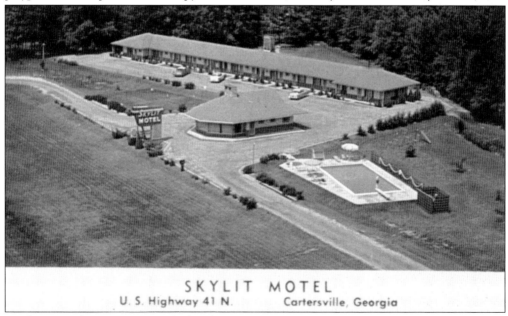

SKYLIT MOTEL
U. S. Highway 41 N. Cartersville, Georgia

As shown in this 1950s postcard, the Skylit Motel uses a swimming pool to lure the traveler by day and an oversized modern neon sign to light the way by night. By the 1950s, when the U.S. 41 and the Skylit motels were built in the Cartersville area on the four-lane Dixie Highway, the mom-and-pop accommodations were being driven out of the market by large-scale motels and corporate super hotels. (Courtesy of Bartow History Center.)

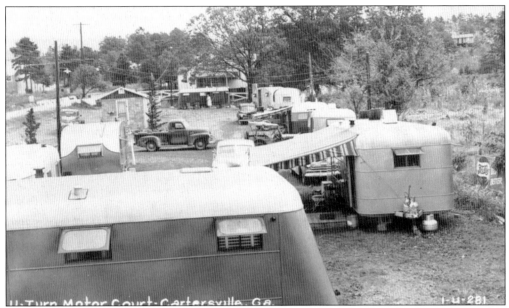

This 1940s postcard of the U-Turn Motor Court in Cartersville shows streamlined car trailers parked for a night or two. As an alternative to the tourist court, the traveler could bring his bed with him. The U-Turn also had a Shell gas station, visible on page 85. (Courtesy of Bartow History Center.)

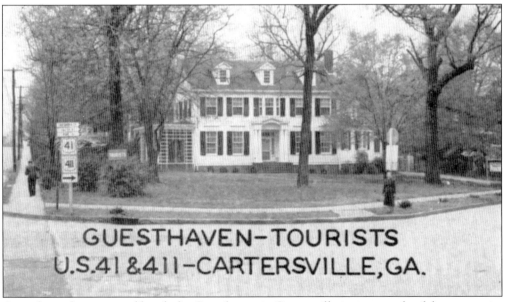

An ordinary home turned hotel, the Guesthaven in Cartersville is an example of the propensity in the South to rent out an extra room for a night for extra cash. All up and down the Dixie Highway from the 1920s through 1950s, a tourist could find signs with such wording as "Room, $1. Heat. Baths. Free Garage." A sign outside on the left side of this postcard simply reads, "Tourists." (Courtesy of Bartow History Center.)

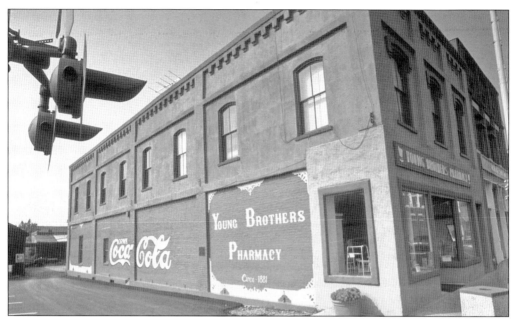

Early in the 20th century, pharmacies and drugstores developed lunch counters and soda fountains to serve the general public. Young Brothers Pharmacy, the oldest continuous business in Cartersville, was one such establishment. The world's first outdoor Coca-Cola wall sign was painted in 1894 (and restored 100 years later) on the side of the building that originally welcomed rail passengers and later greeted northbound Dixie Highway travelers. (Courtesy of Georgia's Dixie Highway Association.)

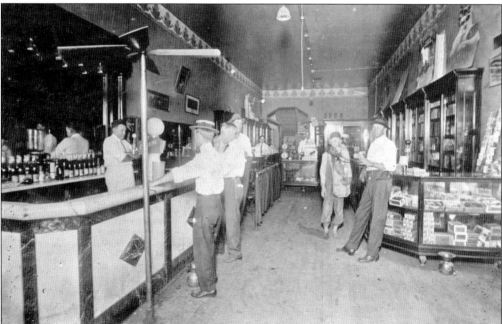

The interior of the Chastain and Morris Drugstore in downtown Calhoun is shown here in 1920. The soda fountain served locals and Dixie Highway travelers. Note the fan attached to the top of a pole in the left foreground. (Courtesy of Georgia Archives, Vanishing Georgia gor516.)

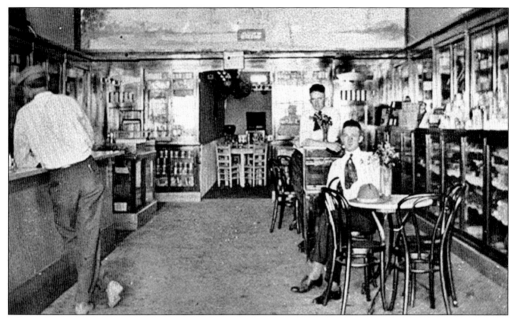

The Jule Neal Drugstore also had a soda fountain in downtown Calhoun, as in this photograph from 1927. A tearoom was accommodated in the rear of the space. Restaurants that catered to the previously mostly male traveling public were not always respectable enough for women and children. Tearooms were opened by women for women and were often located in historic buildings or quaint locations. They were a short-lived success, as they did not cater to the whole family. (Courtesy of Georgia Archives, Vanishing Georgia gor249.)

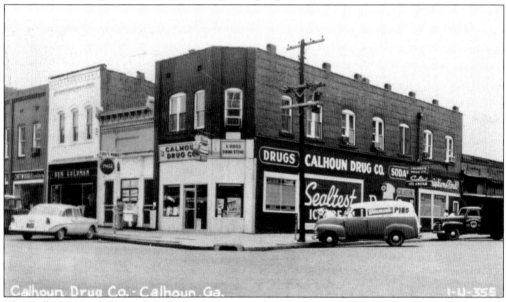

The Calhoun Drug Company was the successor to the Chastain and Morris Drugstore. Sodas were still being offered in 1958, when this exterior photograph was taken. As with the Young Brothers Pharmacy building, the brick wall had become a billboard advertisement for the company and for Sealtest Ice Cream. A Wiseman's Pie truck, parked at right, offers the perfect accompaniment. (Courtesy of Gordon County Historic Society.)

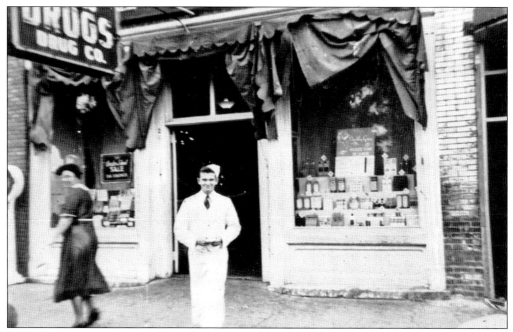

Curbside service was available early on from downtown drugstores and pharmacies even in the horse-and-buggy days. Extension to the automobile traveler was inevitable, as evidenced in this 1937 photograph from Hodges Drugstore on the north park of the Marietta Square. Such curbside service evolved into the large-lot drive-in restaurant, with more space for parking vehicles than could be had on a crowded downtown street. (Courtesy of Georgia Archives, Vanishing Georgia cob392.)

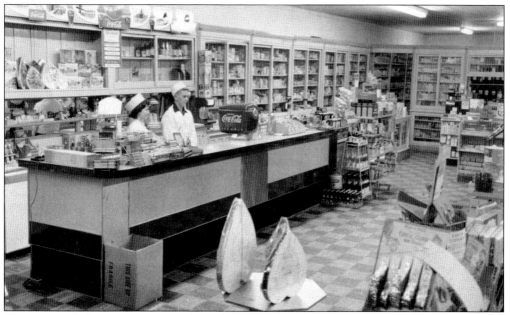

Pharmacy soda fountains continued in popularity into the 1950s. Soda jerks Barbara Brand and Bobby Robbins work the counter at the Acworth Pharmacy, the "Cheerful Druggist," about 1950 in downtown Acworth on the old two-lane Dixie Highway. (Willie B. Kemp collection.)

Questionable local lore relates a tale that Aunt Fanny's Cabin in Smyrna south of Marietta was housed in an actual enlarged slave cabin and that Aunt Fanny was a former slave who lived past 100. Reportedly she was on hand to welcome diners to her establishment and make fantastic fried chicken. Aunt Fanny's Cabin was a popular "Southern theme" restaurant into the early 1990s, with African American wait staff serving white clientele. (Courtesy of Larry O. Blair.)

This 1950s postcard shows the interior of Aunt Fanny's Cabin. In the Great Depression, Isoline Campbell MacKenna sold produce to locals and Dixie Highway travelers from a 1890s cabin on her property. She also made prepared foods from recipes of former slave Fanny Williams. In 1941, she opened Aunt Fanny's Cabin in the expanded 1890s cabin. Aunt Fanny's Cabin was moved from its original site and now houses the Smyrna Welcome Center. (Courtesy of Bob Basford.)

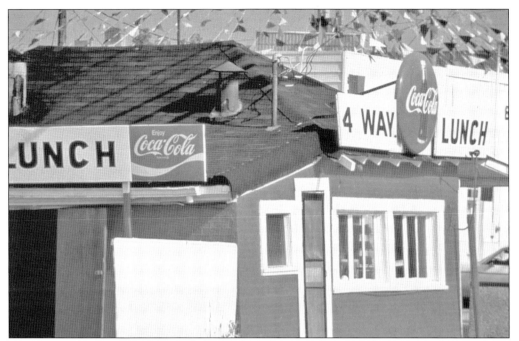

The Cartersville Four-Way Lunch also started at a fruit stand in 1890. By 1931, it had evolved into a hamburger joint with hot dogs, hamburgers, and Coca-Colas priced 5¢ each. Like other eateries of the Dixie Highway era, it was segregated. The "colored entrance" was around the corner on Gilmer Street. (Courtesy of Georgia's Dixie Highway Association.)

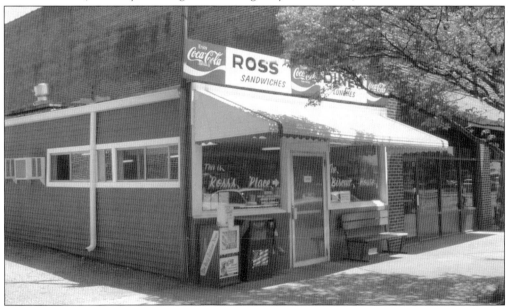

Ross's Diner (also known as the Biscuit House) was established in 1945 by W. D. Ross and Woodrow Bradley as the Ross and Bradley Café. The restaurant resides in a wood-frame building north of the Grand Theatre on the east side of the Cartersville Square. It is little changed today from its 1947 interior with original furnishings and lunch counter. (Courtesy of Georgia's Dixie Highway Association.)

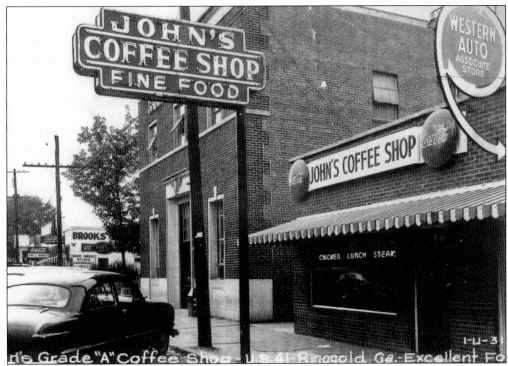

John's Grade "A" Coffee Shop served "chicken—lunch—steaks" from this storefront building as shown in this 1950s postcard. The Dixie Highway traveler would have mingled with the local politicos and the police in this dining establishment in downtown Ringgold. (Courtesy of George Hendricks.)

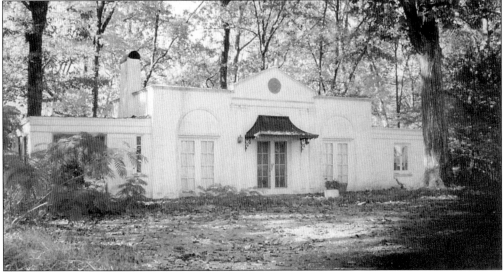

Many locals remember the Guernsey Jug on the Dixie Highway located south of Marietta in Smyrna in the 1930s and 1940s. It was a restaurant with curb service and part of the Creatwood Farms Dairy. The building that housed the restaurant, shown here, was moved about one-half mile from its original location to serve as the clubhouse for a covenant-controlled residential subdivision. (Courtesy of Joe McTyre.)

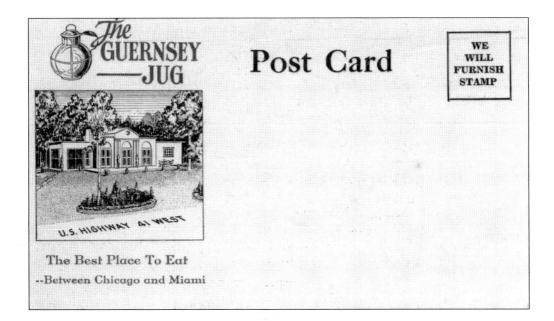

The front of this 1940s postcard of the Guernsey Jug shows the exterior of the building and the boasting slogan. The building was constructed in 1933 and is a City of Smyrna Historic Landmark. The restaurant was frequented by Dixie Highway travelers until the road on which it was located (the old two-lane U.S. 41) was bypassed in favor of the new "Four-Lane." Oddly enough, the back of the postcard directs travelers off the Dixie Highway past the electric streetcar barn to Ashby Street to avoid downtown Atlanta traffic (and the establishments that would have relied on business from the same travelers the Guernsey Jug would miss once the new "Four-lane" was completed). The new four-lane U.S. 41 was under construction at the time and was represented by a dashed line. (Courtesy of Bob Basford.)

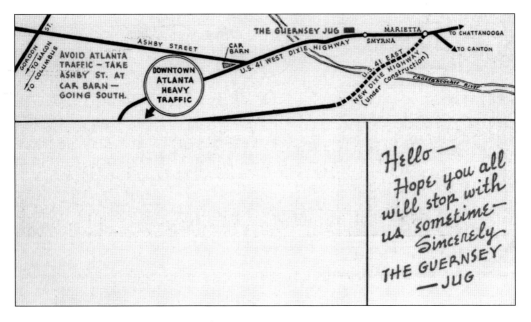

The Chow Time Drive-In in Ringgold is a restaurant built about 1955 on the west side of Nashville Street/the Dixie Highway and is a rare example of a non-franchised hamburger stand still competing with the McDonald's and Burger Kings of the world. The "Home of the Chow Burger" sign, as photographed here, has been altered through the years, but the clock at the top may be original. (Courtesy of Georgia's Dixie Highway Association.)

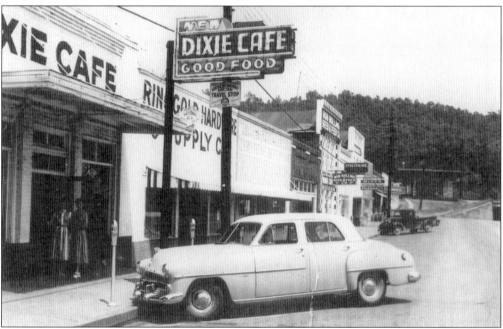

The New Dixie Café was located in downtown Ringgold in the 1930s and 1940s. It is shown here next to the Ringgold Hardware Supply. The café must have served "Good Food," as its sign states and the listings on two travel directories indicate (the National Automobile Association and American Highway Directory). (Courtesy of Bradley Putnam.)

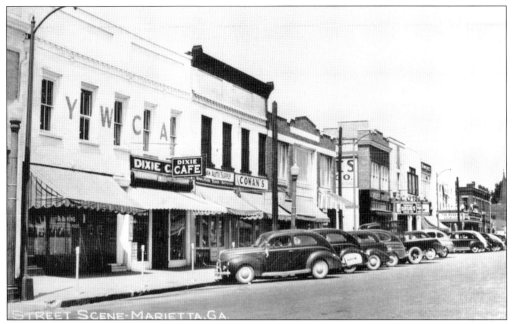

The Dixie Café was housed on north side of the Marietta Square in the early 1940s on the site of Dunnaway Drug Store. As shown on this postcard, it shared a building with the YWCA. As with its namesake in Ringgold, the use of the name "Dixie" may have literally driven additional business to the restaurant from the highway. (Courtesy of Georgia Archives, Vanishing Georgia cob464.)

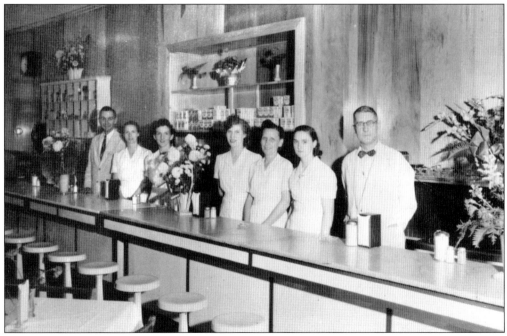

This 1940s postcard shows the interior of the Dixie Café in Marietta. On the left is owner H. Phil Williams, and manager Fred Beck is on the right. The café served a "meat and three [vegetables]" menu. The site is still occupied by a restaurant today with the original floor intact. (Courtesy of Georgia Archives, Vanishing Georgia cob185.)

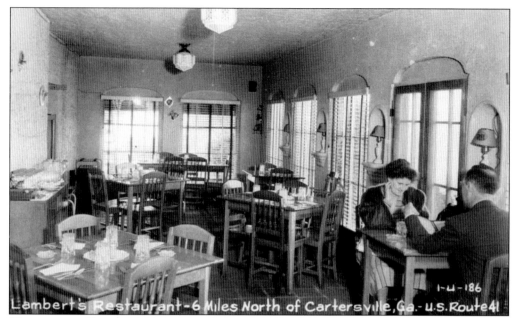

The interior of Lambert's Restaurant in Cartersville is shown in a photograph postcard from the 1950s. Located six miles north of Cartersville near the Greyhound bus station (see Peggy Ann Café on page 110), Lambert's could have been the inventor of the local "Susie Q," a unique taste sensation made by grilling a hamburger bun (meatless) in butter and smothering it in chili. (Courtesy of Bartow History Center.)

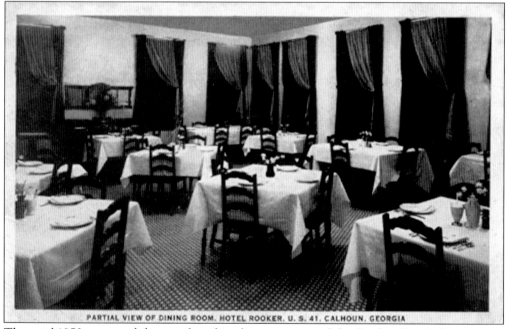

This mid-1950s postcard depicts the white-linen interior of the Rooker Hotel dining room on the Dixie Highway in Calhoun (see page 39 for the exterior photograph). The hotel and dining room were operated by members of the Rooker family. (Courtesy of Gordon County Historical Society.)

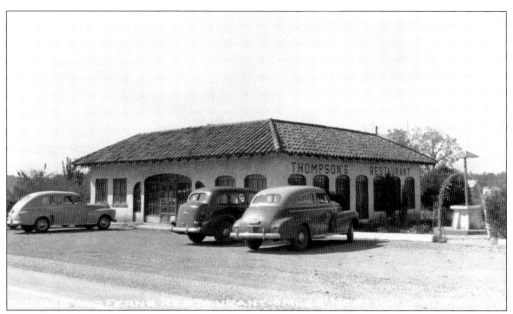

Local lore relates that Thompson's may be the originator of the "Gravy Burger," which is still served in many eating establishments in the Cartersville area. The "Gravy Burger" is a hand-formed hamburger on a bun smothered in brown gravy. This 1950s postcard shows the mission-style architecture of the restaurant that was located six miles north of Cartersville on the Dixie Highway. (Courtesy of Bartow History Center.)

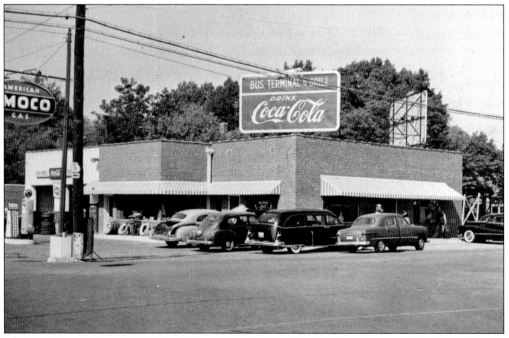

The Bus Terminal and Grill in Dalton was the stop for the Southeastern Greyhound Lines operating on the Dixie Highway. It also served local residents and tourists with meals and Amoco gasoline. The Greyhound mascot is visible at the top of the oversized building sign. (Courtesy of Georgia Archives, Vanishing Georgia wtf173.)

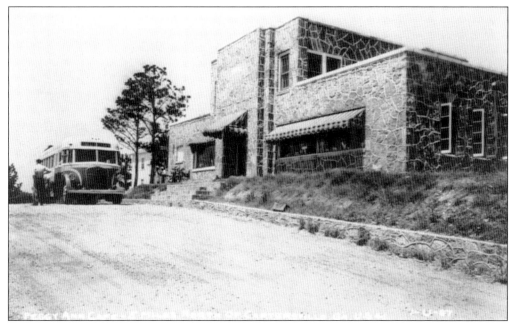

As seen in this 1940s postcard with a bus parked outside, the Peggy Ann Café served as an intercity rest stop for Southeastern Greyhound Lines. The café sold bus tickets, drinks, and food to both local residents and travelers. Its unique fieldstone-sided building was a local landmark on the Dixie Highway. (Courtesy of Bartow History Center.)

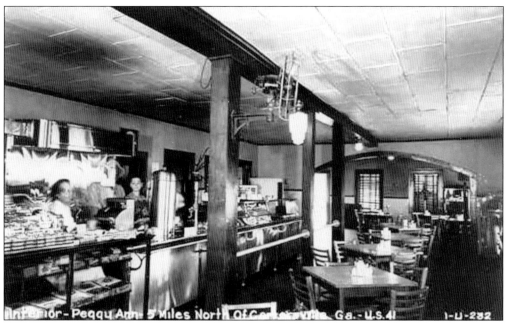

This interior shot of the Peggy Ann Café also dates to the 1940s. The café was so well known in the area for its fine dining that Cartersville folk drove the five miles north of town to it for the culinary experience, even if they were not going to ride the bus. (Courtesy of Bob Basford.)

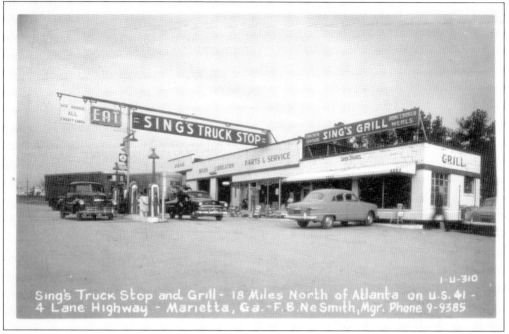

Sing's Truck Stop and Grill - 18 Miles North of Atlanta on U.S. 41 - 4 Lane Highway - Marietta, Ga. - F. B. Ne Smith, Mgr. Phone 9-9385

This 1950s truck stop was a general precursor to the modern convenience store. It combined an eatery with a full-service gas station, both open 24 hours a day. Although Sing's Truck Stop in Marietta was on the four-lane Dixie Highway (18 miles north of Atlanta in Marietta), it is featured here to show the development of roadside services for travelers. The grill featured chicken, seafood, and home-cooked meals. (Courtesy of Bob Basford.)

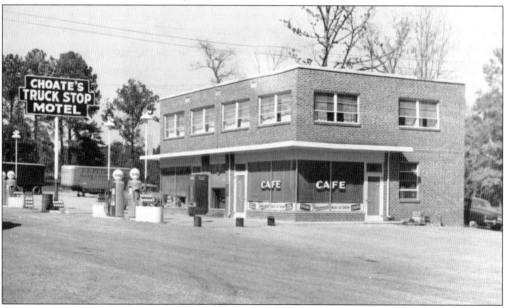

The 1951 Choate's Truck Stop Motel was a one-stop modern accommodation for tourists and truckers with a café, Shell gasoline station, and rooms. The café served steaks, chops, country ham, fried chicken, Paramount dairy products, and Coca-Cola in the vending machine outside. (Courtesy of Georgia Archives, Vanishing Georgia wtf174.)

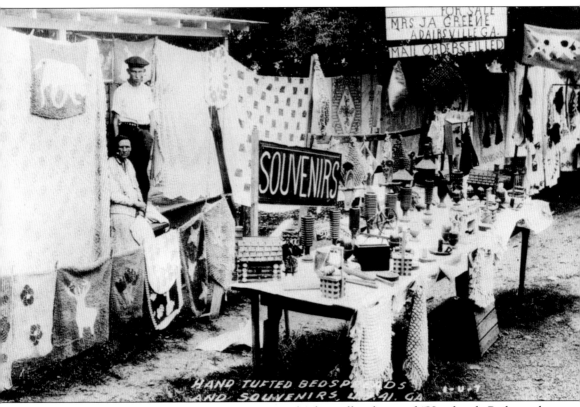

The 1940 roadside stand of Mrs. J. A. Greene of Adairsville advertised "Handmade Bedspreads for Sale" and "Mail Orders Filled." In addition to the chenille bedspreads, she sold pillowcases, toy log cabins, baskets, birdhouses, candles holders, and other handcrafted items. (Courtesy of Bartow History Center.)

Five

DON'T FORGET THE SOUVENIRS!

Purchasing a memento to remember the drive or for someone left at home is an essential part of any road trip. Fresh produce and local handicrafts were sold by the side of the Dixie Highway in north Georgia, but one souvenir was uniquely handmade by local women. Colorful and multi-patterned chenille coverlets were displayed on roadside clotheslines to attract the discriminating buyer. The Northern travelers soon learned to "follow the bedspreads" south from Chattanooga almost all the way to Atlanta.

Catherine Evans Whitener, a farm girl born in the Dalton area in 1880, is credited with launching the cottage industry. Admiring an old family bedspread, she was determined to duplicate the tufting. She revived the American Colonial craft of candlewicking, in which slightly raised, looping stitches were made with white, heavy cotton thread. For Whitener's first spread, begun when she was 15, she made her own thick thread, cut the stitches to create a tufted look, and boiled the cotton sheeting to lock in the needlework.[19] Her first sale in 1900 netted the budding entrepreneur $2.50, and additional orders followed. Soon she was stamping her own designs, teaching other women to stitch the patterns, and selling bedspreads to department stores in Atlanta and Northern cities.

The demand for chenille bedspreads brought other manufacturers into the market. Sheets were imprinted with patterns in "spread houses;" stamped sheets and raw materials were delivered by haulers to thousands of home tufters in north Georgia, Tennessee, and the Carolinas; and the stitched product was returned by haulers to the spread house for boiling and packaging. Mass production developed in the 1930s, as commercial-grade sewing machines were adapted for tufting. The chenille craze made the Dalton area the center of popular fashion. Agents from Northern department stores and home-furnishing businesses came south "in search of innovative products and designs."[20] Factories branched out production into robes, draperies, and small scatter rugs. In the late 1930s, some 90 firms employed roughly 7,000 workers with a combined payroll of almost $5 million.[21]

Further innovations after World War II allowed companies to produce larger floor coverings. As interest in chenille products waned, production of wall-to-wall carpet escalated. Because tufted carpet could be produced more cheaply and with fewer workers in the Dalton area than the traditional woven carpet manufactured in the Northeast,[22] Dalton in time became the undisputed Carpet Capital of the World.

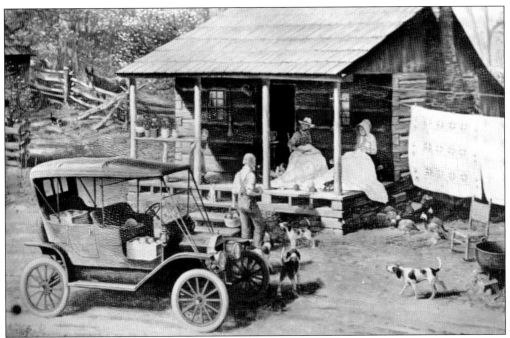

A family of tufters sews on the porch in this period painting from Gordon County around 1920. A hauler is bringing more yarn and supplies to the family. The income from making bedspreads sustained many a north Georgia family through the hardscrabble days following the cotton-economy bust. (Courtesy of Georgia Archives, Vanishing Georgia gor366.)

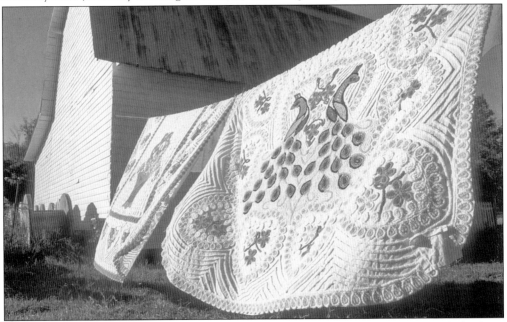

The peacock pattern was one of the most popular, and the bedspreads waving on clotheslines on both sides of the road gave the Dixie Highway the nickname "Peacock Alley." Bedspreads were made and sold from Ringgold Hill to Marietta, with much of the mechanized production occurring in the Dalton area. (Courtesy of Georgia's Dixie Highway Association.)

Ethel Partin Stiles demonstrates the process of making a tufted bedspread in Ringgold in 1934. In the way Catherine Evans Whitener herself made a pattern, a press (in this case a block of wood) covered with meat skins was employed to rub a dashed pattern into the fabric. Stiles used the grease in her other hand to set the pattern into the cloth. (Courtesy of Georgia Archives, Vanishing Georgia cat005.)

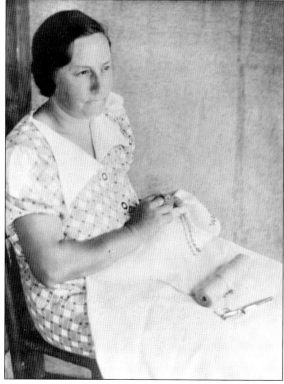

Ethel Partin Stiles followed the rubbed pattern as she stitched the yarn into the bedspread fabric. After the stitched pattern was completed, the material was boiled to lock the stitches in place. This photograph is from the studio of Doris Ulmann and John Jacob Niles. (Courtesy of Georgia Archives, Vanishing Georgia cat008.)

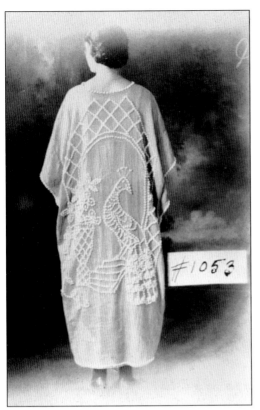

The tufted technique was applied to more than just bedspreads, as evidenced in this 1934 photograph from Calhoun in which Mrs. Ralph Haney models a peacock kimono. By the 1930s, bedspread making had become mechanized, with dozens of firms opening up shops in north Georgia, especially around Dalton. (Courtesy of Georgia Archives, Vanishing Georgia gor466.)

In the mid-1930s, the J. M. Muse Spread Manufacturing Company operated in Sugar Valley northwest of Calhoun and east of Horn Mountain. Unidentified employees are photographed on the company's truck. (Courtesy of Georgia Archives, Vanishing Georgia gor290.)

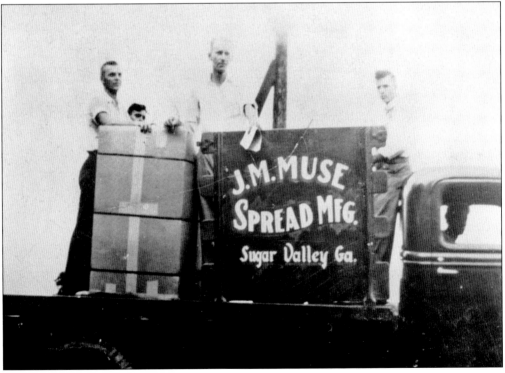

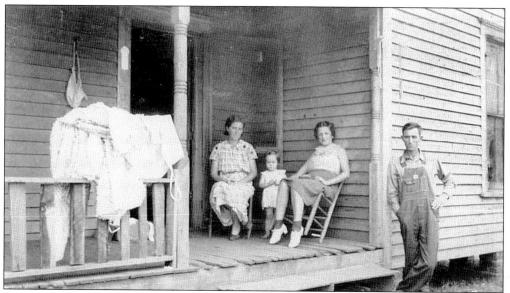

Mabel McClure (seated left), granddaughter Joanne Hall (little girl), and Homer McClure (standing) pose for a photograph with a customer (seated right) on the porch of their home on the Dixie Highway near downtown Kennesaw in 1935. The tourist mailed the photograph back to the family after developing it. The tourist's spread order is on the railing, and above it is the clothespin bag for hanging the spreads along the roadside. (Courtesy of Joanne Hall Garner.)

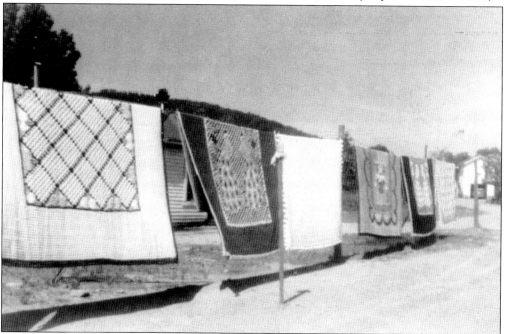

The McClure/Hall story is illustrative of many family bedspread businesses. The McClures made their bedspreads by hand. Their daughter, Homer Lee McClure Hall, and her husband, Carl Hall, mechanized the production. Hall's Bedspread and Chenille Company was located on the Dixie Highway at the foot of Kennesaw Mountain in Marietta. The mountain is visible from the "spread line" here. (Courtesy of Joanne Hall Garner.)

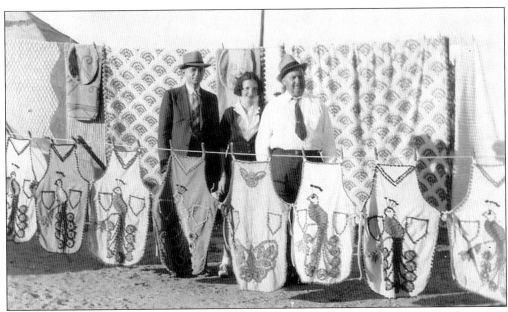

Homer Lee Hall poses between two unknown customers in front of peacock and butterfly aprons. (Courtesy of Joanne Hall Garner.)

The Halls made their own original bedspread, apron, and bathrobe designs in shells, flowers, and leaves. The finished product cost between $4 and $5, with a color pattern priced a few cents more than all white. Pattern No. 133, pictured here, was white with colored flowers and shells. It sold for $4. (Courtesy of Joanne Hall Garner.)

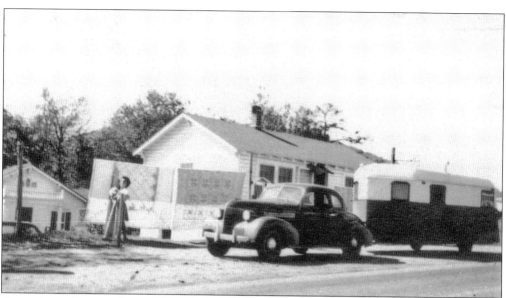

A tourist with an early travel car and trailer stops to look at the Halls' wares in this 1945 photograph. Joanne Hall grew up in the business and earned spending money for her assistance. She started out stamping patterns and later learned to use the machine to stitch the spreads. It was also her job to work the spread line. She is shown here in 1945 hanging out the bedspreads. (Courtesy of Joanne Hall Garner.)

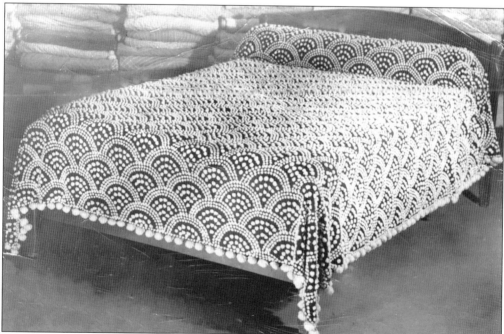

Clark's Chenille was originally built on the Dixie Highway south of Acworth in the 1930s, but it moved to the new U.S. 41 in the early 1950s, when the old two-lane road was bypassed. Clark's bedspreads were originally handmade, like the one shown here, but mechanization soon followed. Another Acworth company, Conway-Noland Toys, produced 8,400 stuffed chenille toys a week in the mid-1940s. (Courtesy of Robert M. Clark.)

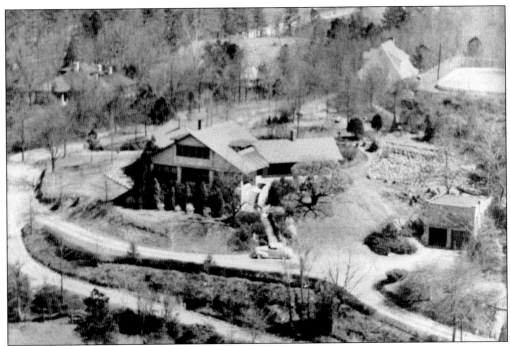

Mount Alto Bedspread was founded by Dr. John Boston in the 1920s. Bedspreads were originally made in the rock garage to the right of his hilltop home on Mount Alto. Dr. Boston's home was built in 1909 by W. Laurens Hillhouse and overlooked the Gordon County Courthouse, which Hillhouse was also instrumental in building. Hillhouse worked on other prominent structures in Calhoun, including the Memorial Arch. (Courtesy of Georgia Archives, Vanishing Georgia gor154.)

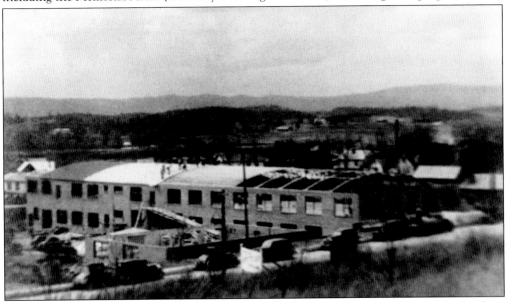

The new tufted mill for the expanded Mount Alto Bedspread is being constructed in this late-1930s picture. Dr. Boston's son and son-in-law followed in the family business by founding such companies as Georgia Textile Corporation; Georgia Tufters, Inc.; Brown Laundry, Inc; and Georgia Tufted Sales, Inc. (Courtesy of Gordon County Historical Society.)

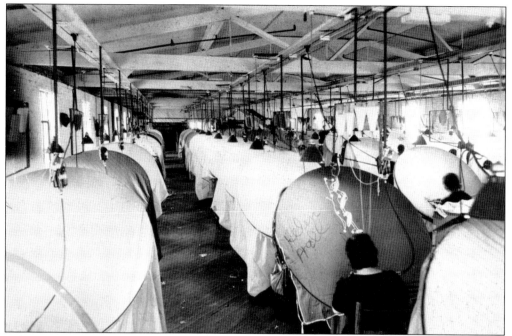

Cabin Craft Bedspread Company in Dalton was one of the earliest mechanized firms and pioneered the electric needle-punch gun. This 1941 interior photograph of the needle-punch room shows workers threading the colored yarn to punch or embroider the fabric in the large embroidery hoop. The needle-punch gun was later adapted for use in custom-designed area rugs. Cabin Craft had a reputation for quality work; one of its bedspreads graced Scarlett O'Hara's bed in the movie *Gone with the Wind*.[23] (Courtesy of Georgia Archives, Vanishing Georgia wtf225.)

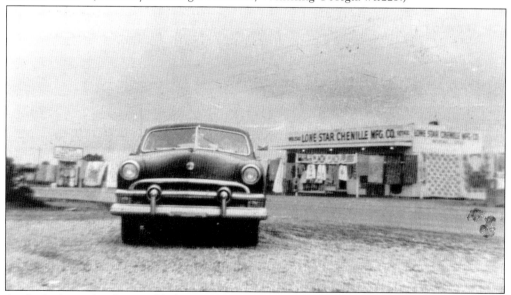

As the bedspread industry added area rugs and then wall-to-wall carpeting, the roadside stands evolved as well from simple clotheslines to block buildings. Bedspread production continued well into the 1950s. Lone Star Chenille Manufacturing was located in a long line of wholesale/retail dealers along the Dixie Highway in Tunnel Hill. (Courtesy of Bradley Putnam Collection.)

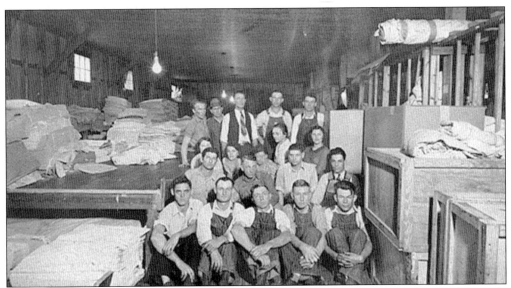

In this photograph, taken around 1950 at the Blue Ridge Spread Company, members of the mostly male design-stamping department pose next to their worktables. Tufting companies that chose to relocate out of north Georgia had limited success with skilled workers, a fact that was attributed to the familiarity north Georgians had acquired in working with "yarns and fibers from the early hand-tufting days."[24] (Courtesy of Georgia Archives, Vanishing Georgia wtf041.)

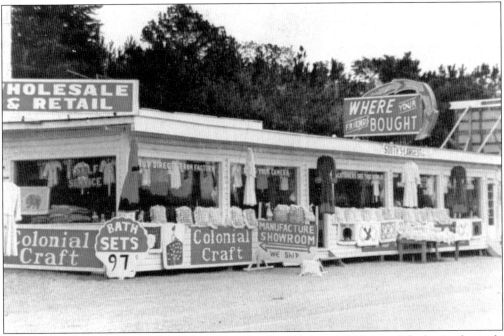

Colonial Craft in Tunnel Hill billed itself as the South's largest bedspread dealer in the early 1950s. Operated by Elbert and Georgia Lee Putnam, it invited the public to see the manufacture showroom and buy direct from the factory. Bath sets were only 97¢. Colonial Craft in Tunnel Hill reminded the tourist to "bring your camera." (Courtesy of Bradley Putnam.)

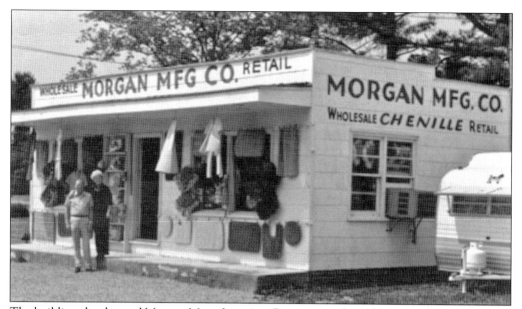

The building that housed Morgan Manufacturing Company in the 1950s is one that still remains along the Dixie Highway today near Tunnel Hill. Tank sets, toilet-lid covers, tank covers, and inset floor rugs are visible in the front right display. At this time in the 1950s, the chenille bedspread business had evolved into almost a caricature of itself. (Courtesy of Georgia's Dixie Highway Association.)

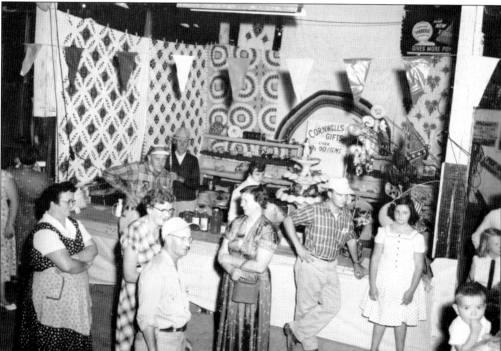

Shoppers found many wares for sale at Cornwells Gifts in Dalton in the 1950s, including straw hats, baskets, animal figurines, a water fountain, flags, and—of course—chenille bedspreads. (Courtesy of Georgia Archives, Vanishing Georgia wtf292.)

Twin Size Spreads in all Designs 50c Less

All Orders Shipped promptly C. O. D.

Prices Listed are F. O. B. at Our Factory
TUNNEL HILL, GEORGIA

Write for information on Items not Listed

Owned and Operated by

Robert E. Putnam

P. O. BOX 1 ❖ TUNNEL HILL, GA.

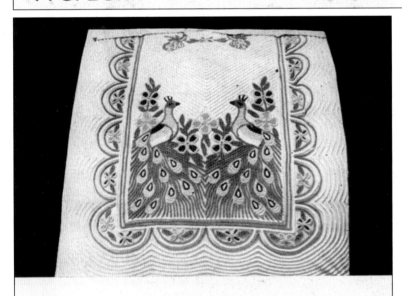

R-22 Peacock

Heavy single needle spread. Deep pile chenille. 9 to 11 beautiful, bright colors. On white, blue, rose and gold fast-color sheeting.

Price $ 9.50

Customers ordering a bedspread from Put's Chenille Center in Tunnel Hill could browse through the company's selections, including the famous peacock design. The catalog dates from around 1948. The address on the catalog— P.O. Box 1—is still in use today by Dalton Carpet Jobbers, a present-day reminder of the evolution from chenille bedspreads to carpet in Dalton. (Courtesy of Bradley Putnam.)

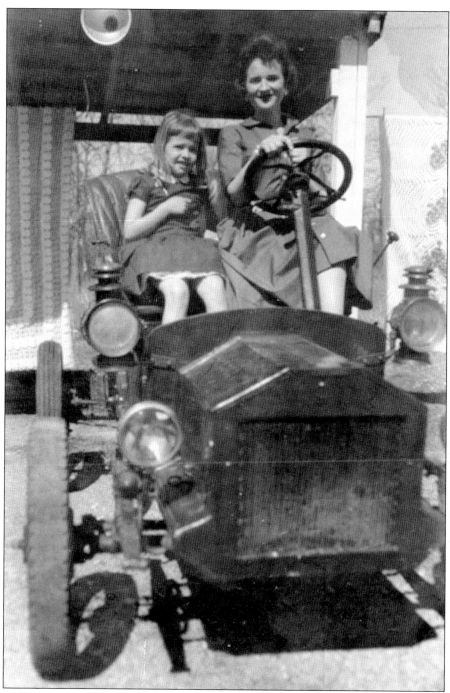

This roadside attraction located by a spread factory between Adairsville and Cassville is both a symbol of a bygone era and an example of a uniquely American tourism phenomenon: the "photo op." The 1950s tourist could have a photograph made with a giant rabbit, an elephant, or a replica car complete with bedspreads in the background. Donna Davis McElveen and her mother Sarah Jean Middleton Weaver had this snapshot made in 1958 to remember their travels along north Georgia's Dixie Highway. (Courtesy of Jean Middleton Weaver.)

NOTES

[1]Kenneth T. Jackson, *Crabgrass Frontier: The Suburbanization of the United States* (New York, NY: Oxford University Press, 1985), pp. 159, 163.

[2]Ibid., pp. 161, 162.

[3]Howard Lawrence Preston, *Dirt Roads to Dixie: Accessibility and Modernization in the South, 1885–1935* (Knoxville, TN: University of Tennessee Press, 1991), pp. 60, 61.

[4]Georgia Department of Transportation, Annual Report (Morrow, GA (Documents stored in Drawer 311, Box 13-15)), 1927.

[5]Jeffrey L. Durbin, "Dixie Highway Tour #1: Bedspreads and Bypasses," in *Driving the Dixie: Automobile Tourism in the South* (Unpublished Tour Guide: Society for Commercial Archeology, 1998), pp. D24–26.

[6]*The Dixie Highway,* (Chattanooga, TN: The Dixie Highway Association, May 1918), p. 10.

[7]Ibid., (May 1920), p. 6.

[8]Federal Writers' Project, *Georgia: A Guide to its Towns and Countryside* (Athens, GA: University of Georgia Press, 1940), p. 300.

[9]Clifford M. Kuhn, Harlon E. Joye, and E. Bernard West, *Living Atlanta: An Oral History of the City, 1914–1948* (Athens, GA: University of Georgia Press, 1990), pp. 172–174.

[10]Durbin, p. D19.

[11]Federal Writers' Project, p. 307.

[12]Ibid., p. 300.

[13]Ibid., p. 307.

[14]*The Dixie Highway* (October 1924), p. 3.

[15]Tim Hollis, *Dixie Before Disney: 100 Years of Roadside Fun* (Jackson, MS: University Press of Mississippi, 1999), p. 22.

[16]Ibid., pp. 23, 24.

[17]Preston, p. 132.

[18]Chester H. Liebs, *Main Street to Miracle Mile: American Roadside Architecture* (Baltimore, MD: The John Hopkins University Press, 1995), p. 77.

[19]Randall L. Patton, *Carpet Capital: The Rise of a New South Industry* (Athens, GA: University of Georgia Press, 1999), p. 85.

[20]Ibid., p. 87.

[21]Durbin, p. D14.

[22]Patton, pp. 120, 121.

[23]Ibid., pp. 94, 95.

[24]Ibid., pp. 103, 104.

BIBLIOGRAPHY

Belasco, Warren James. *Americans on the Road: from Autocamp to Motel, 1910–1945*. Cambridge, MA: MIT Press, 1979.

Capps, Michael. *Kennesaw Mountain National Battlefield Park: An Administrative History*. Marietta, GA: Internal Pamphlet by National Parks Service Southeast Region, Cultural Planning Division, 1994.

Carver, Martha, Jeffrey Durbin, Claudette Stager, et al. *Driving the Dixie: Automobile Tourism in the South*. Chattanooga, TN: Unpublished Tour Guide by Society for Commercial Archeology, 1998.

Civilian Conservation Corps. *Camp Educational Report*. Marietta, GA: Unpublished report in Kennesaw Mountain National Battlefield Park Archives, November 17, 1938.

The Dixie Highway. Chattanooga, TN: Monthly Magazine by the Dixie Highway Association, 1917–1927.

Federal Writers' Project. *Georgia: A Guide to its Towns and Countryside*. Athens, GA: University of Georgia Press, 1940.

Georgia Department of Transportation. *Annual Report*. Morrow, GA (Documents stored in Drawer 311, Box 13-15), 1919–1950.

Hollis, Tim. *Dixie Before Disney: 100 Years of Roadside Fun*. Jackson, MS: University Press of Mississippi, 1999.

Jackson, Kenneth T. *Crabgrass Frontier: The Suburbanization of the United States*. New York, NY: Oxford University Press, 1985.

Jennings, Jan, ed. *Roadside America: The Automobile in Design and Culture*. Ames, IA: Iowa State University Press, 1990.

Kennesaw Mountain National Battlefield Park. *Oral History of Carless Collins by Retha Stephens*. Marietta, GA: Unpublished manuscript, conducted January 26, 1985.

Kuhn, Clifford M., Harlon E. Joye, and E. Bernard West. *Living Atlanta: An Oral History of the City, 1914–1948*. Athens, GA: University of Georgia Press, 1990.

Liebs, Chester H. *Main Street to Miracle Mile: American Roadside Architecture*. Baltimore, MD: The John Hopkins University Press, 1995.

Patton, Randall L. *Carpet Capital: The Rise of a New South Industry*. Athens, GA: University of Georgia Press, 1999.

Preston, Howard Lawrence. *Dirt Roads to Dixie: Accessibility and Modernization in the South, 1885–1935*. Knoxville, TN: University of Tennessee Press, 1991.

Stager, Claudette, and Martha A. Carver, eds. *Looking Beyond the Highway: Dixie Roads and Culture*. Knoxville, TN: University of Tennessee Press, 2006.

Vieyra, Daniel I. *Fill 'Er Up: An Architectural History of America's Gas Stations*. New York, NY: Macmillan Publishing Co., 1979.

ACROSS AMERICA, PEOPLE ARE DISCOVERING SOMETHING WONDERFUL. *THEIR HERITAGE.*

Arcadia Publishing is the leading local history publisher in the United States. With more than 3,000 titles in print and hundreds of new titles released every year, Arcadia has extensive specialized experience chronicling the history of communities and celebrating America's hidden stories, bringing to life the people, places, and events from the past. To discover the history of other communities across the nation, please visit:

www.arcadiapublishing.com

Customized search tools allow you to find regional history books about the town where you grew up, the cities where your friends and family live, the town where your parents met, or even that retirement spot you've been dreaming about.